Alive to Art:
EXPLORING
Colours and Crafts

José Llobera

TRANSLATED AND ADAPTED BY

W. J. Strachan

Crane Russak · New York

Exploring Colours and Crafts

American Edition 1976
Published by

Crane, Russak & Company, Inc.
347 Madison Avenue
New York, N.Y. 10017

ISBN 0-8448-0869-5
LC 75-37208

© Copyright 1970 by
Jose Llobera and by
Editorial AFHA Internacional, S.A.
Barcelona

English Translation
© Copyright 1972 by
Frederick Warne & Co. Ltd.
London

Printed in Spain

CONTENTS

INTRODUCTION

This book takes you on another journey into the world of art, a journey that really should have no end because in the ups and downs of daily life this other, second world can always offer you refreshment and an escape from tedium and anxieties. This second world is a mysterious symbol of a world within, that portion of your inner self which feels the urge to express itself, to communicate, to feel and appreciate beauty . . . to create.

Those who have a genuine vocation for an art career have the prospect of living permanently, if insecurely, in this fascinating world. Most people, however, have other destinies. Nevertheless, the help and instruction you will find in the *Alive to Art* books will not be useless; it will always be there for you to call upon whenever you feel inclined.

Today, when there are so many opportunities for appreciating art and making it your own, some education in the subject is a necessity. To lack artistic sensibility is a new form of illiteracy, perhaps the worst, since it means a narrowness of outlook, a cramping of the spirit.

The present part of the series offers a period of experimentation, exchange of ideas, choices of media. Where possible you should make opportunities for comparing notes with fellow-students and friends. Mutual criticisms can be useful especially if they are frank and when an expert opinion is not available. Civilization, like aesthetic evolution, arises from encounters between different generations. Such encounters can be fruitful even on a personal and less exalted level.

Awareness

To work consciously means fulfilling our intentions, in other words, knowing what we are doing. From now on you must no longer merely trust to luck or intuition but use the skill you acquire to achieve the effects you are aiming at. Knowledge, however, is not a technique and it is therefore difficult to teach in a practical way; it is awareness, and this can be acquired only through practice and experience. To achieve this objective it is recommended that you undertake more thoroughly the experiments contained in *Introducing Subjects and Skills* and *Portraying People and Places* of this series, striving to reach a higher standard of results.

The principles concerning some basic lessons which you will find set out on this and succeeding pages, can be applied to all your work. They will enrich it and give it an added artistic validity.

The psychology of colour

While making colour arrangements, you will have realized that colour is more than a decorative element. Each colour has a language of its own, capable of producing particular sensations and of conditioning the atmosphere of any subject.

Remember that colour is a physical element and, as such, follows certain optical rules which you must master if you are to obtain attractive effects and give meaning and atmosphere to your paintings.

Realistic representation

Nature must be your great master. As is shown in the other two books of the series, you cannot stylize, individualize and interpret pictorially what you do not really know.

Your work must always be based on truth. Only by taking reality as a starting-point can you learn to know forms, volumes, colours and the principles of movement . . . on the foundations of which you can give shape to your own work that will be both real and personal.

Starting from reality, you are of course free to adapt it.

Synthesis

With the different sources of colour at hand and familiarized with the forms confronting you, you can now embark on the most important part of the artistic process—the synthesis. Synthesizing is an artistic activity in itself since it means reducing what one sees and knows to its essence.

Art exists in all objects but it is not enough to copy them with a brush or a palette-knife to bring them to life. You have to extract beauty from them and know about the technique for expressing it.

These precepts will help you to produce more mature results. However, knowledge passes beyond these technical boundaries; it implies ability to execute the work with impeccable technique and absolute clarity, knowing how to place the subjects between the margins of your paper so as to achieve a perfect balance of white framework or areas of white. It implies a professional attitude, neglecting no detail of execution and presentation.

It is not enough to have ideas, you need to be able to carry them out properly and in a definitive form. Do all the necessary preparatory work in such a way that the final result is not provisional. Otherwise it would be a deplorable waste of effort. Only too often initial merit is spilt by faulty execution. The counsel of perfection, you will say!

THE PSYCHOLOGY OF COLOUR

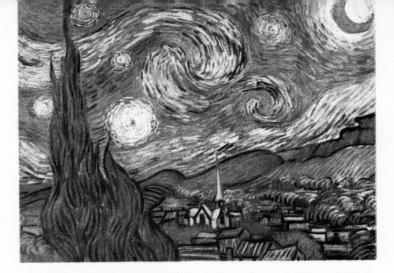

You already know something about colour. Most of us have got through whole boxes of pastels in our early childhood.

In this urge to colour we are all to some extent self-taught; we know something about it, we are aware of its influence:

'This red room is really aggressive!'

'What an attractive colour this peach is!'

'That tie doesn't go with your suit!'

We continually hear such comments and make them ourselves. More often than not they are justified: the room is certainly a nightmare, the peach really is an appetizing colour and the tie is dreadful. All of which shows that our reaction is instinctive rather than scientific and that colour affects us psychologically.

If we learn its possibilities we can create settings, express desires and evolve harmonies at will.

Look at the two pictures on the right. The first was painted in cool colours (blue, blue-green, violet-blue). It is one of Van Gogh's masterpieces, The Starry Night, *the nocturnal setting of which is particularly original. The second painting* Dante's Barques *by Delacroix gives us an example of warm colours (red, orange, yellows, browns) which are well suited to a dramatic subject.*

The theory of colour

It is necessary to distinguish between colour and colours.

Colour is a physical phenomenon produced by the decomposition of light.

Colours are pigments which serve to represent colour.

The additive synthesis is the conjunction of rays of various colours which together produce white light. To obtain pure light three beams of light (dark-blue, green and orange) must coincide.

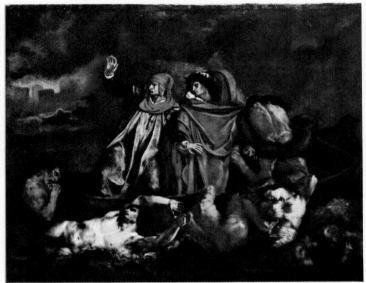

The subtractive synthesis is the mixture of pigments or the superimposition of pigmented surfaces. The basic colours in this case are blue, yellow and red which together go to make black.

From the artists' point of view the most interesting process is that of subtraction since they are working with pigments and not beams of light. However, as you will be seeing, the problem of physics is always connected with the artistic, since we cannot use the pigments without taking their optical characteristics into account.

Let us begin with the **rainbow,** technically known as the **spectrum,** produced by the decomposition of light by a prism. The spectrum contains all the basic colours, that is those which combined variously can give us all the colours found in nature. It is composed of six colours in the following order: red, orange, yellow, green, blue and violet. At the two extremities of this scale are the infra-reds and ultra-violets; but these, being invisible to the human eye, are of no interest to the artist.

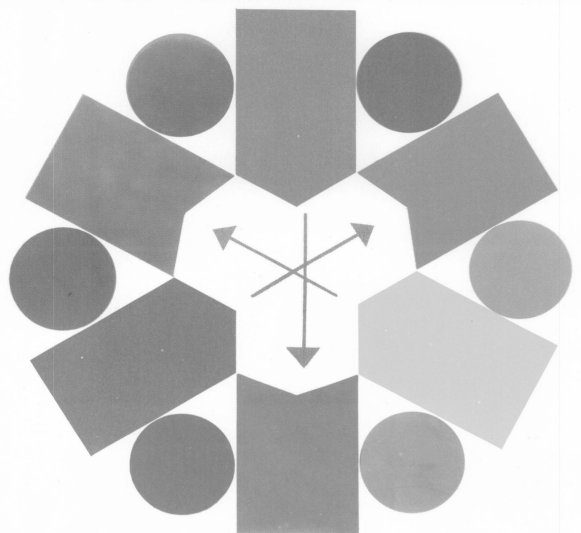

If we arrange these basic colours in a circle we can draw various conclusions. First, we discover three colours which are colours in their own right, that is they are not made up from any others. These are **red, yellow** and **blue** and are called **primary** colours. Between one primary and the other, we find a **secondary** colour, obtained from the sum of the two primaries. These secondary, composed colours are **orange** (red and yellow), **green** (yellow and blue), **violet** (blue and red). The small circles represent the **tertiary** and intermediate colours. From these we can compose an infinite scale.

Opposite each primary colour we find a secondary colour, always made up from the sum of the two other primaries, that is to say it complements the synthesis. For this reason they are called **complementary colours.** The arrows indicate the three combinations of complementaries.

The juxtapositions of complementaries

Nothing produces a stronger contrast than the juxtaposition of one complementary with another. These are red and green, blue and orange, yellow and violet. Colour is a physical problem and the eye dislikes the juxtaposition of pure complementaries. In fact if you look at these juxtapositions, you will note how unharmonious and unpleasant they are to the eye. In painting these are known as colours of maximum contrast.

Theoretically the sum of two complementaries should produce black, but in painter's pigment they produce brown.

Optical reaction to complementaries

Physically speaking, colours are the optical reaction to particular rays of light reflected back from the object. This explains why certain colours, especially the complementaries, have an unharmonious effect on our eyes.

You have the proof of the strange reactions that colours produce when you look at them in the experiments shown on this page. Start with the red flower. Stare at it for a minute without taking your eyes off it. When the minute is up, close your eyes for a few seconds and shift your gaze to the centre of the white square on the right and you will see the same flower appear on the blank surface, but this time it will be green, the complementary colour of red.

A similar effect will occur with the blue shape which will produce an orange image. End the experiment with the violet heart which will produce a pure yellow image. Other colours would produce a similar phenomenon, even black and white which are logical complementaries.

In the circles below you can see another experiment showing the importance of juxtapositions. The only colour changed is the background colour, but it exercises an optical influence on the others through contrast.

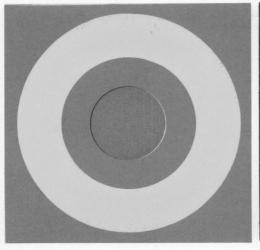
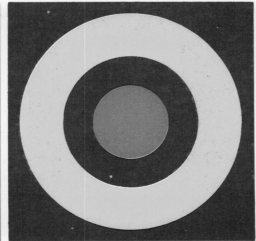
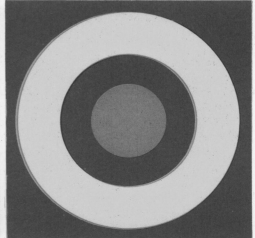

Colour harmonies

To produce maximum harmony in the juxtaposition of colours the latter should be near each other in the spectrum. In this way 'melodic scales' or colours of one tone are obtained, influenced to a greater or lesser extent by the other colours. This type of harmony is the easiest and least exacting to produce, and when in tune with the subjects it is very effective.

The first example, a detail of the painting by Renoir *La Première Sortie,* shows us a harmony of warm colours especially in the background areas.

In the picture by Manet *Races at Longchamp* the scale is composed of cool colours more suited to this theme.

Courbet's *The Corn Sifters* offers a larger variety of tones. In fact it is composed of one primary colour and two secondaries.

The final example by Manet, *Sails at Argenteuil,* shows us something different: **point of contrast.** In this case, it is the small orange house, a colour that contrasts with the dominant melodic scale of the subject.

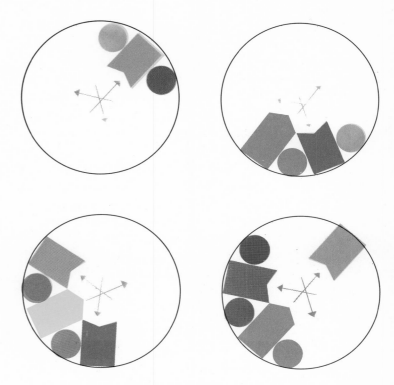

These diagrams represent the four scales corresponding to the four pictures shown below. Naturally they take account of the main colours and not of the areas of 'sfumatura' or transition in which other colours intervene.

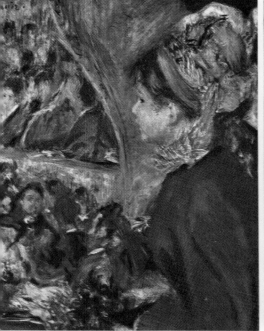

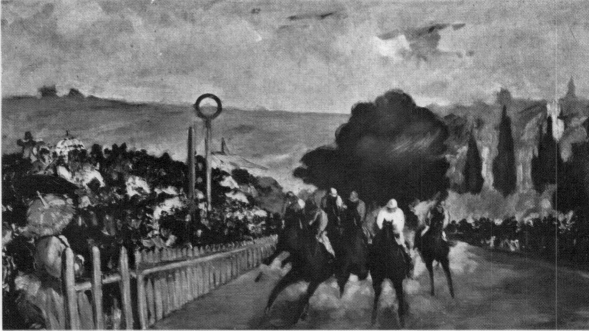

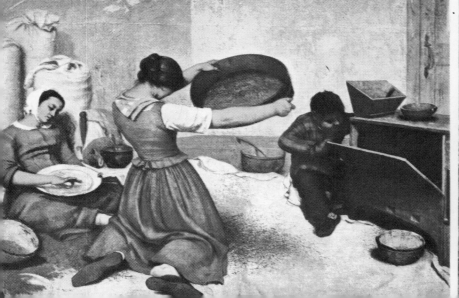

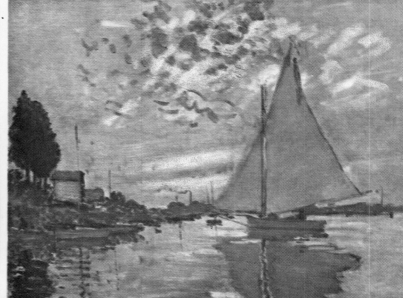

You may well be thinking that the art of picture-making cannot be limited to such tonalities and although the results are harmonious, they lack richness of colour. And it is true. We should not neglect any colour. Nature teaches us that we cannot produce an attractive and harmonious result using just any colours unless we plan these elements beforehand.

The examples shown on the previous page are only a starting-point which will help us to produce what nature achieves intuitively, namely by mixing all the colours with an overall tonality. Such an overall tonality always exists. In fact the colours of objects will not be the same on the beach (where sky and sea diffuse a blueness) as they would among mountains at sunset (where the pink light of the sun will warm the tones).

Even the air has substance and colour. It exercises a pervading influence on the tonality of various objects situated at various distances. And then there is rain and mist and artificial light whose dominating yellow has been noted by all painters.

Therefore to make a successful use of all the colours we wish, without upsetting the general tonality, we can mix them with one primary colour so that the whole picture 'breathes' this subtle intonation.

The three colour examples on this page show you the same subject constructed with different tonalities: red, yellow and blue respectively.

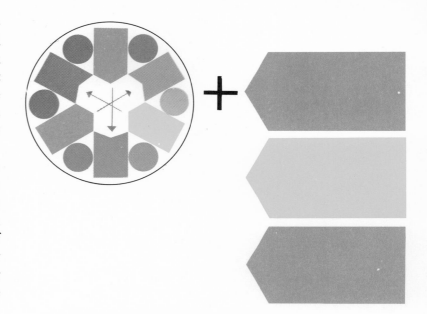

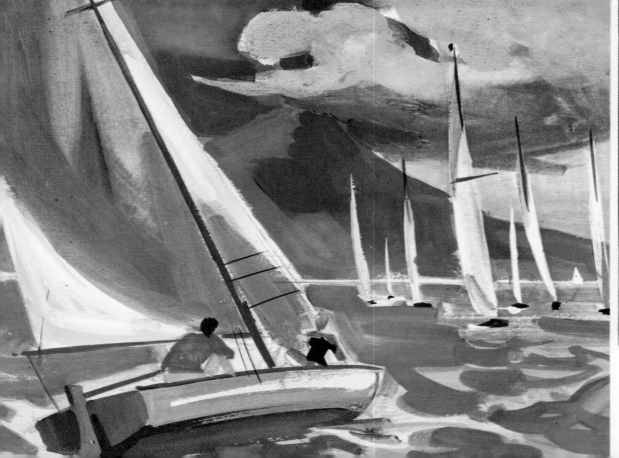

The use of contrasts

The technique of contrast is the opposite of that of harmony. Thus, to produce the maximum contrast one must juxtapose the complementary colours (blue and orange, yellow and violet, red and green). Complementaries are required when you want to give luminosity to certain details or a touch of liveliness to a unified tonality. If you use the complementaries indiscreetly, the results are harsh, but sensibly used, they lend richness of colour, light and vitality to the subject.

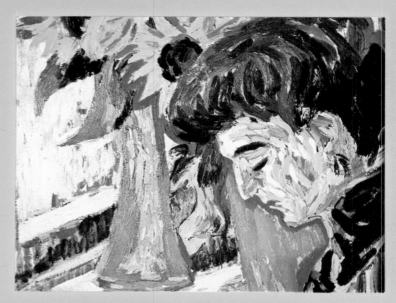

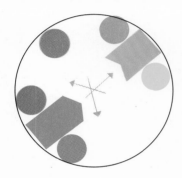

Harmony between pure complementaries

Bonnard: *La Salle à manger sur le jardin (The dining-room overlooking the garden)*

Note this picture's luminosity. Only with the intelligent use of complementaries was it possible to create this contrast between natural light beyond the window and the warm artificial light inside the room. The sky would not seem so blue if the window-frame and surrounding area were not so warm. In addition, the intervention of violet intensifies the yellow of the dishes. This is a classic example of the heightening of light by the use of complementaries.

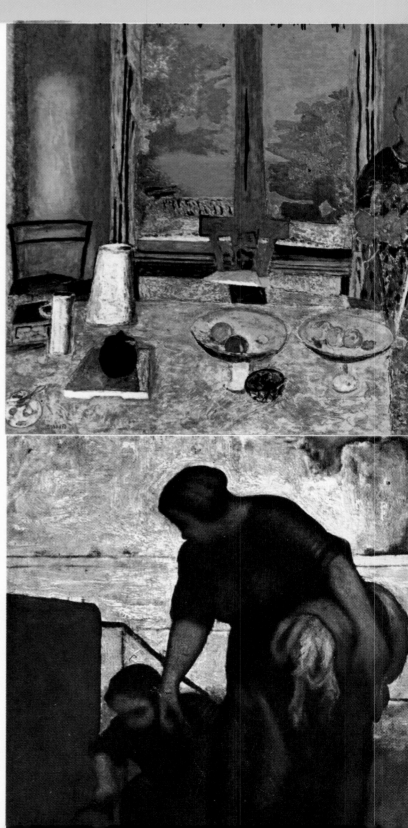

Harmony of complementaries of different intensity

Daumier: *La Blanchisseuse (The Laundress)*

Colours do not always have to be pure like those of the spectrum. Indeed browns, black, white along with very many other mixed colours play their part in painting. These pigments which we call neutral are used to lighten or darken the various pure colours.

The example shows us the juxtaposition of two complementaries: violet (in the foreground) and yellow (in the distance). However, the contrast here is not limited to colours. In addition chiaroscuro (or light and shade—see *Introducing Subjects and Skills* pages 48 to 53) emphasizes the contours of the figures and serves to tone down the opposition of the two complementaries.

Harmony between tonal complementaries

Degas:
Course de Gentlemen
(The Gentlemen's Race)

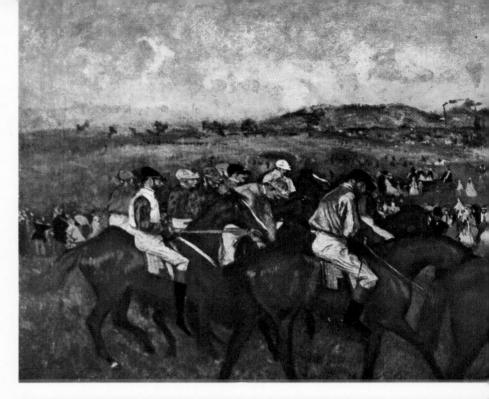

In this painting Degas was trying to bring out the chestnut colour of the horses against the green of the grass, but to avoid too violent a contrast he 'worked' the colours first, so that the juxtaposition should not be too striking. Note that on the green of the grass occurs a certain invasion of red, whilst on the red of the horses the invasion is more or less maroon, namely a reddish-green.

The picture has a warm tendency, intensified by the blue-grey of the sky.

Harmony by semi-contrast

Courbet: *La Toilette*
de la mariée
(The Bride's Toilet)

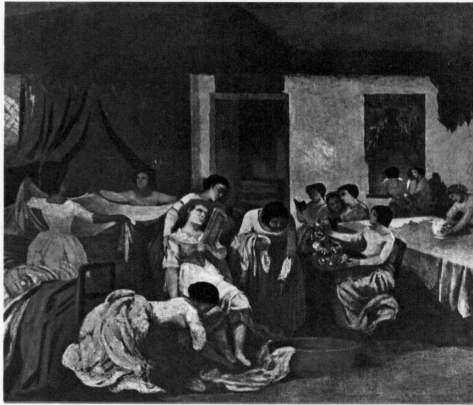

In painting this picture perhaps Courbet was conscious of the blue and orange contrast, but gradually, as he painted, he toned the colours down so that the contrast based on complementaries should be composed of closer tones of the spectrum than are blue and a warm yellow.

The aim of this contrast was to focus interest on the seated girl, the subject of the theme. Imagine how the meaning of the picture would change if the yellow figure had been of another colour. This way of individualizing the subject is a pictorial resource not to be underestimated.

Harmony of complementaries of different tonality

Renoir: *Le Moulin*
de la Galette

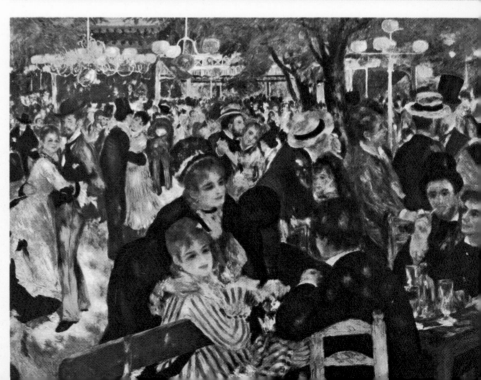

This painting could be called a study in a melodic scale (violet, blue-violet, blue-green) except for occasional touches of complementary colours (yellow, orange-yellow). These areas of contrast are limited in such a way as not to upset the general harmony. Instead, they provide variety to the whole which would otherwise be too cold. The seat, particularly, and the straw boaters lend an indispensable luminosity to this complex subject.

Harmony through chiaroscuro

Nature is not composed exclusively of colours, but essentially of **light and shade.** Colours change, of course, according to the amount of light they absorb or reflect. A blinding light will make colours look pale, whereas deep shadow will make it difficult to distinguish one colour from another.

In painting to say 'light' is equivalent to saying 'white' and 'shadow' to saying 'black'. So we can modify colours by adding white or black (in the case of black, we mix in fact dark colours which produce less muddy shadows). The colour change effected by chiaroscuro is so great that in proportion to the amount of white or black added, the complementary colours also lose' their aggressiveness. Look at the diagram on the right: the violet and green strips are both affected by black and white. Only in the centre of both strips do the colours offer the maximum contrast. These same colours, according to the amount of white or black mixed with them, show a diminishing contrast as they move from the centre of the strips until, at the two extremes, they are almost in harmony.

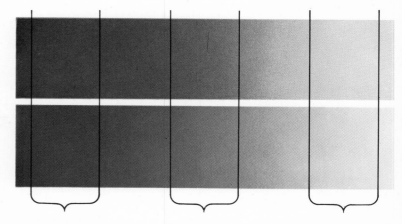

HARMONY THROUGH BLACK MAXIMUM CONTRAST HARMONY THROUGH WHITE

Harmony by shadow

Now look at the reproduction, St. George and the Dragon *by Eugene Delacroix. The technique used in this painting is the converse of the following example. We have a warm and a cool area here too but the tonality of both has been produced with the help of dark colours. This system gives the painting a sense of mystery and drama suited to the subject.*

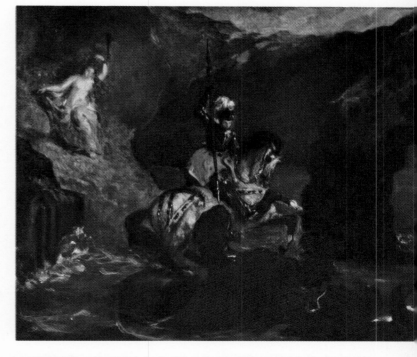

Harmony by light

Monet's painting Femme à l'Ombrelle *which you see on the right, is a clear example of how light—that is white—is the perfect moderator of contrasts. The cool colours (at the top of the picture) and the warm ones (at the bottom) do not clash thanks to the skilful elaboration of the colours through the addition of white and other light colours.*

The feeling of light is successfully conveyed and gives a work in which the real subject is the sun an exceptional naturalness and vivacity.

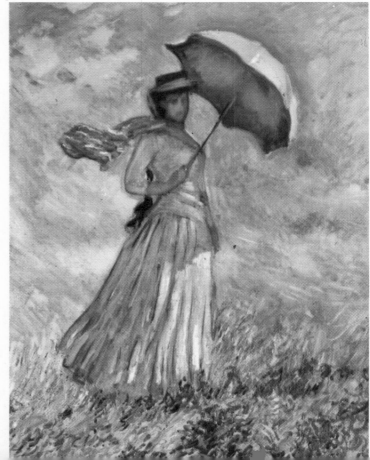

WORKING FROM
REALITY

The main consideration here is how we address ourselves to reality. For the moment we can neglect the lesson on synthesis, since the more we can appreciate the reality of the forms and colours, the more prepared we will be to make an intelligent synthesis. Technically, you will find this is our most difficult lesson because it imposes a very hard discipline. The representation of reality is always very exacting, very complex. You cannot cover up by reliance on gimmicks. It requires effort, technique and observation. So this lesson is the acid test of your ability.

Ability is not of course synonymous with art, but in its absence art fails to attain its purpose; the artist's hand can betray his idea. Imagine, for example, an author who had all the ingredients for greatness except that he knew no grammar! We are now dealing so to speak with the orthography and calligraphy of art.

Let us begin by stating that even this type of picture offers not a few artistic possibilities since producing realistic subjects does not imply a photographic likeness. Look at the example reproduced. Above all glance at the model and you will see that the bare reality of the photograph does not seem particularly rich in possibilities. Compare the photograph, however, with the illustrator's work and you will agree that without moving too far away from reality he has produced a very different final result. Note the almost imperceptible but very effective process of simplification in the two pencil sketches. Observe further the expert brush-strokes, the perfect harmony of the colours and the clean execution in body colour.

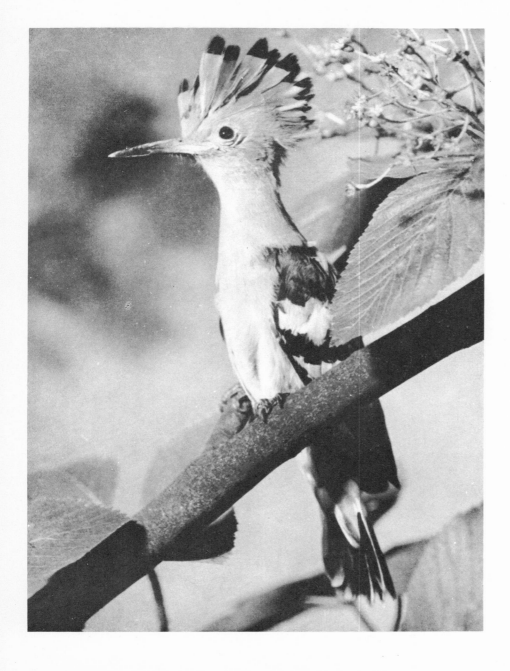

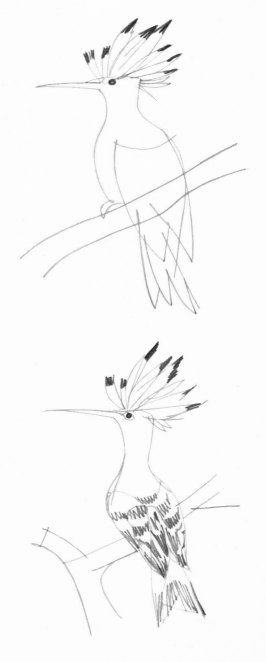

The interpretation of reality

From the moment when we first open our eyes, we become increasingly aware of shapes, light, shadows, colours, distances . . . As we grow up, we become able to judge distances, the degree of relief in objects, by eye, thanks to the efforts we have made in our infancy to adjust our senses to reality. You will have noticed the way babies stretch their arms up, trying to reach the ceiling lamp from their cot.

For a pictorial interpretation of reality you need fresh training of the eye to enable you to judge distances, light, shadow, colours etc. since seeing reality is not by any means the same thing as representing it. In these three books you will gain some experience of all this, and as your learning process becomes more conscious, you should improve—or at least try out—your capacity for interpreting, by drawing a great deal from life (not from photographs which facilitate the problems) using suitable objects you find about the place.

First make a composition of the actual objects and then, by educating your eye to the relative dimensions of the objects chosen, try to reproduce them on paper, paying special attention to proportions, light and shadow and the placing of each element. A method often practised for this kind of measurement consists in holding up a pencil at arm's length and measuring off the proportion of the various items with this improvised scale.

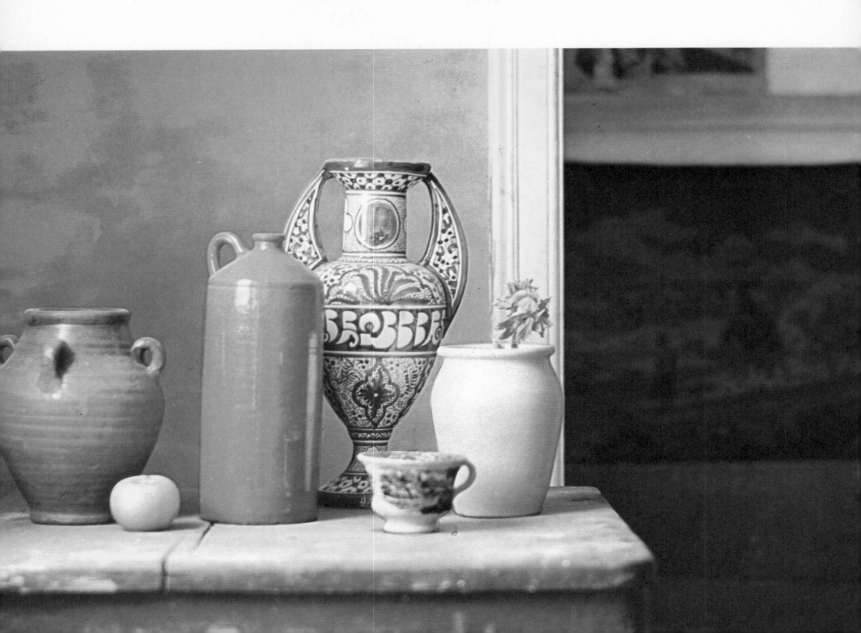

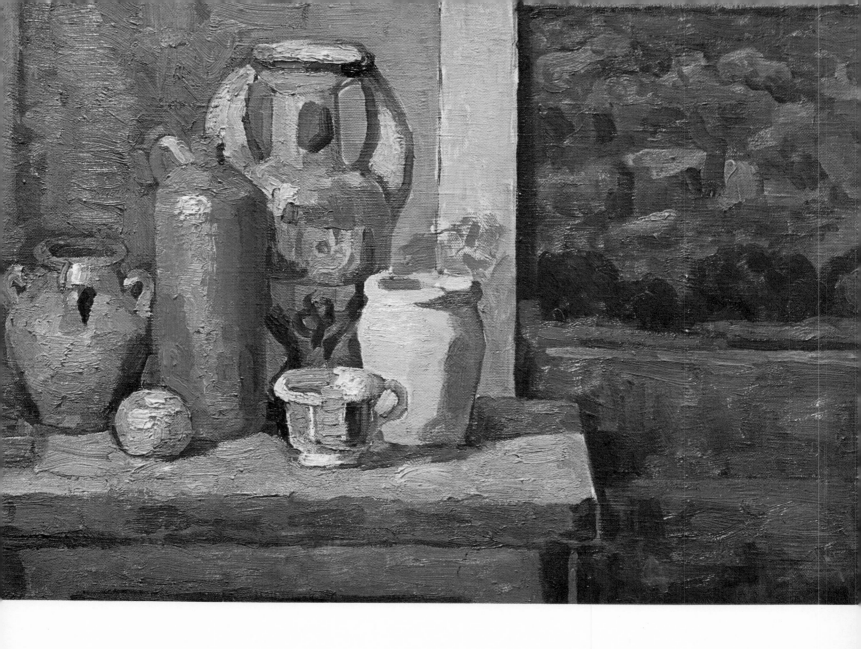

The representation of colour

We are now facing a somewhat difficult problem. We are so accustomed to reality that we are scarcely aware of the sfumatura, tones and vibrations that colours offer in nature. We say, 'This bottle is transparent. This dish is red. This orange (obviously) is orange.' How wrong we are! This bottle has scores of colours in its transparency; this dish is relatively red but its shadows are violet and the lights are yellowish. Finally, the orange is not only orange but contains passages of green, yellow and red. . . The essential thing is to individualize the colour of the lights and the shadows, the tones hidden in the reflections, in the material, in the setting . . . to construct the colours as nature does by exploiting the whole spectrum, at the same time exaggerating the passages of sfumatura so that they seem creatively natural.

We decided to illustrate this lesson with an oil-painting. This technique in fact offers a greater elaboration of colours and a clearer identification of sfumatura because of the strong brush-strokes, which reveal the structure of the shapes and colours in an unambiguous and telling way.

The present subject reproduced may not be rich in details but it is in content and purpose. In short, despite a minimum of descriptive elements it is a successful evocation, and this also thanks to the identification of the important areas where light, shadows and the innumerable colours of nature create what we know to be reality.

THE PORTRAIT

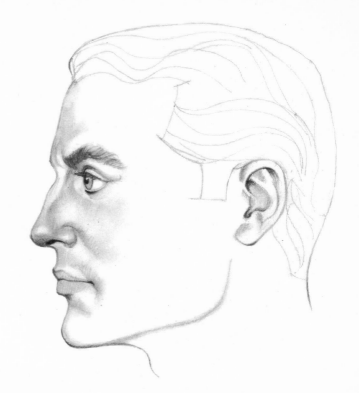

If you ask a painter or draughtsman what he is most requested to do, he will certainly reply, 'Portraits!' In fact when we meet an artist we feel tempted to ask him to draw us. There is something magical about someone who is capable of such a skill. We cannot therefore discuss drawing from life without dwelling on this important aspect of it.

Of all subjects the human face offers the most variety, and precisely because of this it is easy to identify. Fortunately for artists not all faces are as perfect as the idealized one depicted on the right. Let us examine the main variations.

 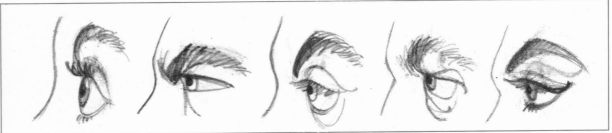

The eyes *The eyes are always dominated by the eyebrows and their variations are infinite. They may be arched, wide, bushy, deep, small, large. Sometimes they indicate age (first on the left) or sex (last on the right).*
The eyelids and the placing of the pupil relative to them are determining factors in the facial expression.

 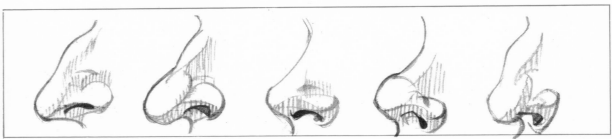

The nose *How many problems ugly noses have raised! But what a telling feature it is. There are so many types. However, the variations are always dictated by the bone structure, the length, and the muscles at the tip. Yet the nose betrays in a certain way the sex of the subject, at least in theory.*

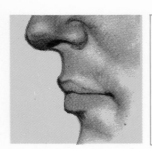 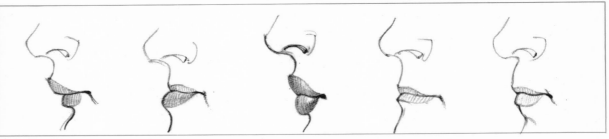

The mouth *The mouth and the muscles controlling it are the chief mechanics of facial expression. For this reason we shall study it at length and sum up all the possible variations.*
For the present we will consider only the lips and their relation to the jaw which may jut out or recede and thus modify the mouth formation.

How to obtain a likeness

As we have already stated, no face is perfect. Thus, to obtain a likeness we have to learn how to **see** and **represent** these imperfections. It is unjust to call these individual features imperfections, since they lend interest to the face and reflect the individual personality. According to the proverb 'the face is the mirror of the soul'. The question of obtaining a perfect likeness depends on characterizing the features of each individual and noting **dimensions** and **proportions** in the face.

The imaginary superimposition

Here is a formula for individualizing the characteristic features: make a mental comparison of your subject with the portrayal of the 'perfect' man or 'standard' face. Let us take a practical example:

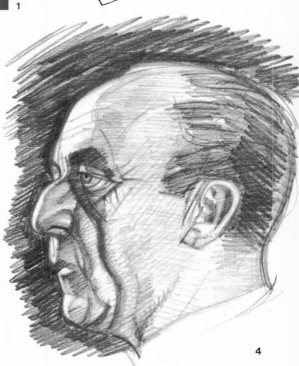

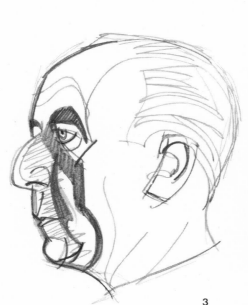

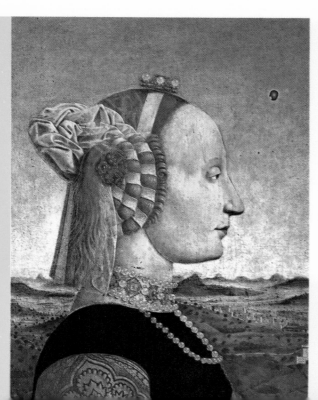

1. *We will take for our model the middle-aged man who appears in the photograph. Theoretically it would be easy to produce a successful likeness by tracing the photograph down to the minutest details, but the result would be poor and feeble (apart from the fact that tracing is valueless in itself).*

2. *This is the mental process: superimpose your subject on the 'standard' face* and measure the differences: *nose longer, forehead more receding, eyebrows lower, eyes more prominent etc.*

3. *Now you should exaggerate the said features. You will be afraid of producing a caricature, but don't worry, this very fear will act as a brake to your hand.*

This exercise helps to familiarize you with the subject.

4. *Finally construct your portrait, always exaggerating the imperfections of your model and his or her expression.*

As you look at the finished example, you may not have noticed but it is very different from the photograph. It is more exaggerated. For this reason portrait-drawings have more expressive force than photographs.

Many painters have been superb portraitists, but among so many the one who comes closest to the theme developed in these pages is Piero della Francesca. His sober, linear style, apparently simple but so expressive, teaches us what a portrait can be and indicates the vast gulf that separates it from modern photographs.

In the portrait of *Battista Sforza, Duchess of Urbino* no less than in that of *Federico da Montefeltro*, the characterization is the predominant note. This exceptional power is largely due to the exaggeration of the individual features of the two subjects.

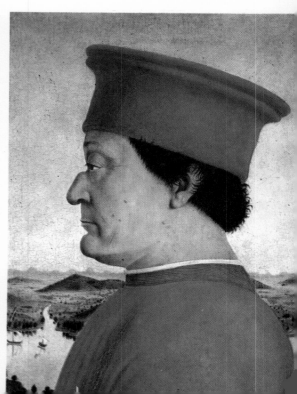

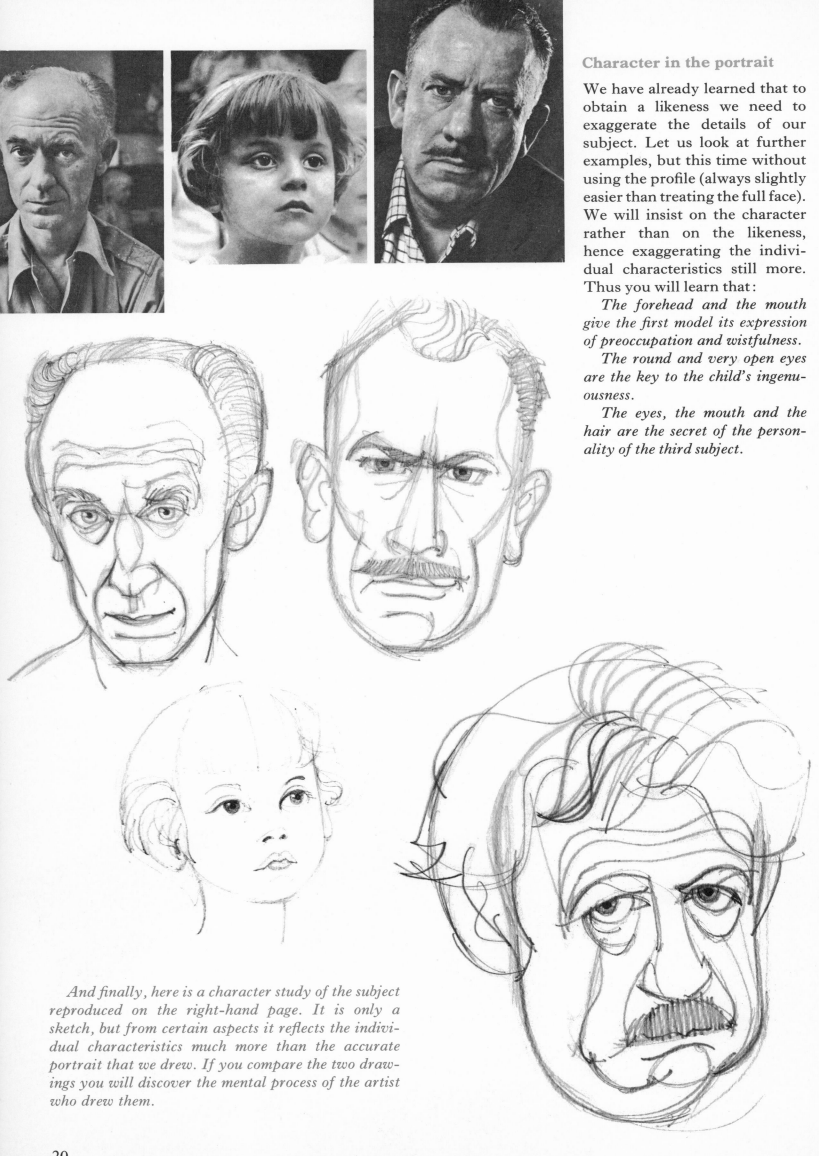

Character in the portrait

We have already learned that to obtain a likeness we need to exaggerate the details of our subject. Let us look at further examples, but this time without using the profile (always slightly easier than treating the full face). We will insist on the character rather than on the likeness, hence exaggerating the individual characteristics still more. Thus you will learn that:

The forehead and the mouth give the first model its expression of preoccupation and wistfulness.

The round and very open eyes are the key to the child's ingenuousness.

The eyes, the mouth and the hair are the secret of the personality of the third subject.

And finally, here is a character study of the subject reproduced on the right-hand page. It is only a sketch, but from certain aspects it reflects the individual characteristics much more than the accurate portrait that we drew. If you compare the two drawings you will discover the mental process of the artist who drew them.

20

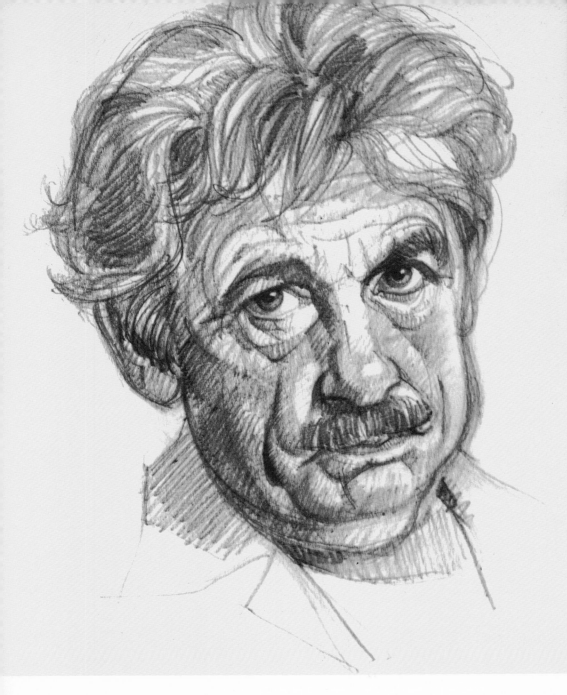

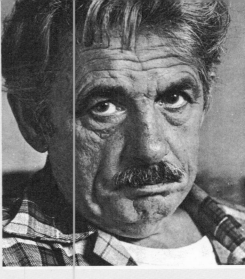

Values in the portrait

Values are variations or gradations of tone as affected by light and shadow, independent of the actual colours of the object. Light and shade in portrait-painting is the most effective means for obtaining likeness or character since the details animate and effectively explain the different parts of the face, their form and quality.

It is a good idea to use two pencils to indicate values, an ordinary one (HB) and a very soft one (3B etc.). The first is for the lines, the second to reinforce the light and shade once this factor is determined.

Shadows should be constructed with soft strokes executed with the pencil held in an almost horizontal position, thus avoiding over-precise lines.

We cannot close this chapter devoted to character in the portrait without a reference to Modigliani, one of the artists who was most successful in integrating the forms of his portraits into his personal vision, and interpreting their personality. His original approach to beauty and his strange elongated faces have a fascination of their own, a character apart. Look at the apparent ingenuousness of his Portrait of a Young Girl *and the force of expression of the* Portrait of Anna Zborowska.

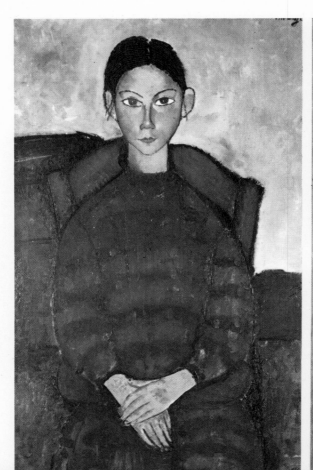

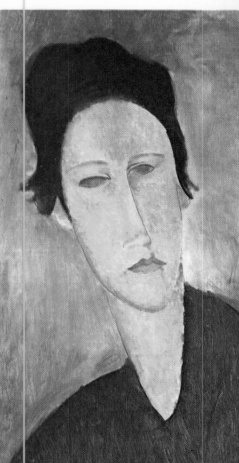

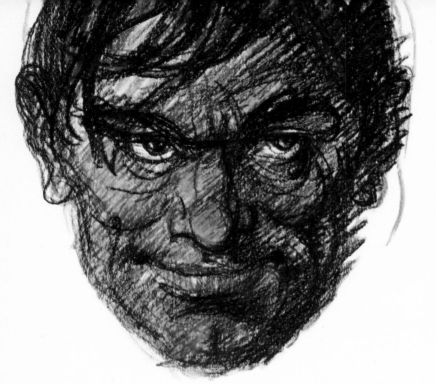

What colour is the flesh?

This is a question we must all have asked at one time or another. Despite the fact that flesh obviously has a definite colour, there is no easy reply. And it is not easy because the human face is too important as a subject for it to be limited to one possible colour. Thus, let us say at once, flesh in painting is any and every colour, depending on light and shadow and the nature of the subject.

The example on the left demonstrates this. Here the maximum amount of colour has been used—expressly. If you allow for a certain exaggeration, it produces an interesting result.

However, flesh certainly has a definite colour. Normally you need three colours to represent it: **light vermillion, yellow ochre** *and* **white** *(the latter only if you are painting in oils or body colour). The mixture of all three (in different proportions) will produce a range of colours similar to those of flesh tones.*

You can get even closer to reality, if you wish, by enriching this scale with a touch of yellow and a slight shadow of light green.

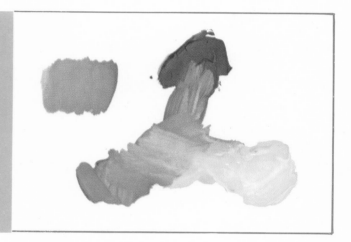

You should now consider the various tones this scale of flesh colours may assume in a particular subject. There is a great difference between the colour of a man's complexion compared with a child's or a woman's. These variations can only be obtained by modifying the proportions of the colours in the mixing.

Example of a complexion composed of warm tones. This range is very suited to middle-aged subjects, and lends character to facial expression.

This example, on the other hand, is in cool tones, very appropriate to juvenile and female subjects. The range used here gives faces a feeling of youthfulness.

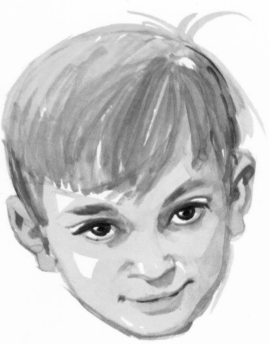

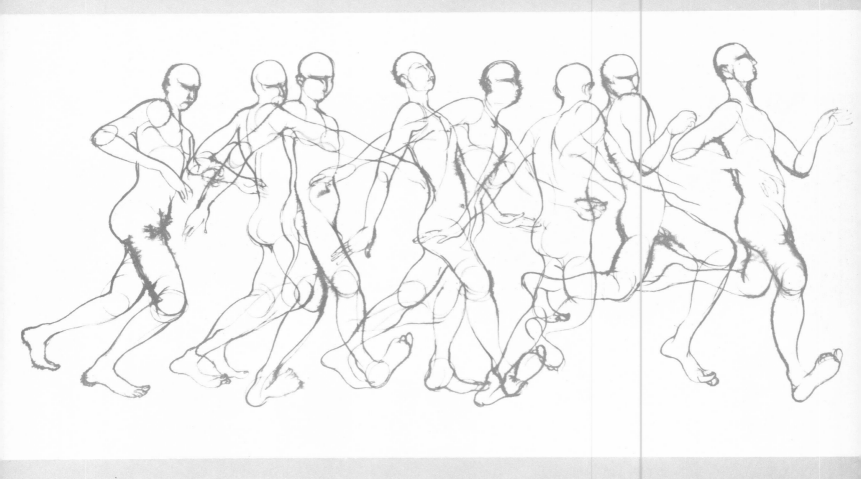

THE RAPID SKETCH

When you draw from life, you will not always have posed subjects at your disposal, so convenient for transferring to paper. When the subject is in motion, you are up against the time-factor, and you must adopt a very different approach. It is no longer possible to erase, correct, and make an accurate copy of each detail. You scarcely have the time to draw at all!

The whole problem is one of memory, the faculty of retaining the image in your mind even after the subject has vanished. Some people have a natural aptitude for this work, but, as we shall soon see, memory can be cultivated.

In the rapid sketch **we do not draw directly from the model but from the mental image we retain.** However, this does not mean inventing but copying a recollection, which is a very different thing. And here there can be no deception; one can see at a glance whether a sketch has been made honestly from reality or in an arbitrary way. There are certain details that only reality alone can

suggest, and it is precisely these points that can give you away.

Essentially the rapid sketch has a basic function —**to capture movement.** We can say that the real subject is movement. The rapid sketch is not only a fascinating but above all an extremely instructive experiment. The artist who captures movement on paper, the grace and details of a subject in motion, shows he possesses a first-class sense of selection since, at a glance, he has managed to isolate the essential parts of the subject and instinctively suppressed the rest.

Any subject is suitable for this exercise provided it is in movement. However, if we want a really interesting model, we should go and look for it where there is a choice of subjects, not one but many. The best place for this (provided you are not put off by the presence of passing admirers) is the most crowded street in your town or village, the place where people go for a stroll, unconsciously offering you a complete gallery of curious types. Take up your observation post on a public bench and prepare to take aim.

The rapid sketch consists of a preparatory part (the choice of subject) and three definite stages: observation, capturing the movement and the final checking.

Ready? Subject in sight!

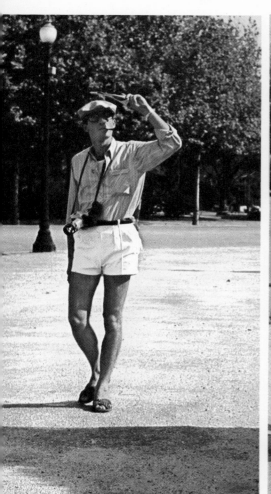 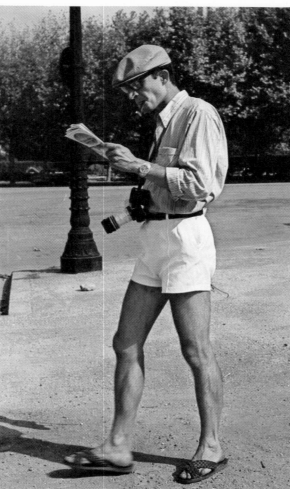 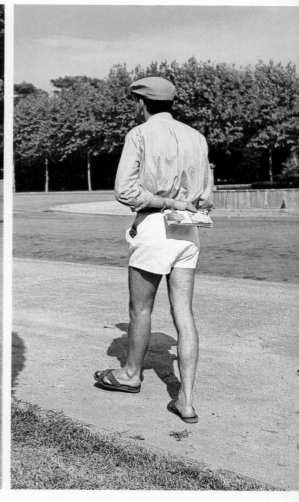

1. Observation

A tourist is approaching. He is strolling (certainly somewhat wearily). He is looking in all directions and his clothes make him an interesting subject.

At this stage you should waste no time. You must make a mental image of him: semi-circular grey cap, thin face with prominent jaw, pipe, light buff shirt (rather baggy), white abbreviated shorts, camera slung round his neck . . . Note all the details. The more you assemble the more realistic will be the resultant drawing.

2. Capturing the movement

Now and only now is the moment for drawing—just those few seconds while the subject passes in front of us. Quick! Forget the details. Concentrate your full attention on the movement you intend to record . . . Now!

Semi-circular cap, bent neck and shoulders (long back), camera on his stomach, legs splayed out, loose sleeves, and . . . Enough! The time has elapsed. We cannot draw any more. Now we must resume our observation of our model as he moves off.

3. Checking

This stage is necessary if we are to take full advantage of the brief time during which our subject is in close range. His position has changed. Now he is moving away (too hurriedly—has he spotted us?). So all we can do is to check the picture we still retain of him. Yes, his shoulders are rather drooping, the shirt is definitely too full, the shorts really short—and tight, the feet—feet? What are they like? Large, in sandals, long legs, map in hand . . .

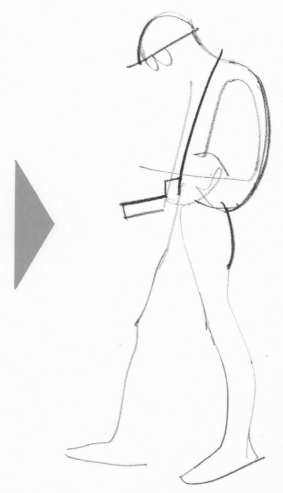

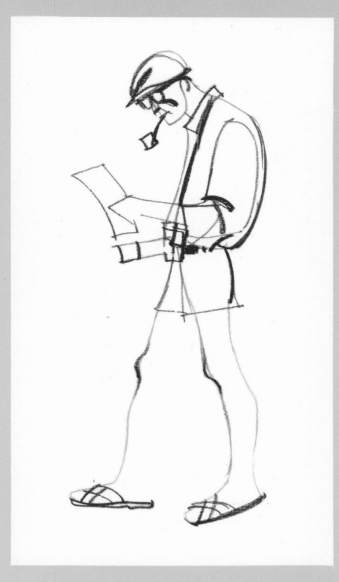

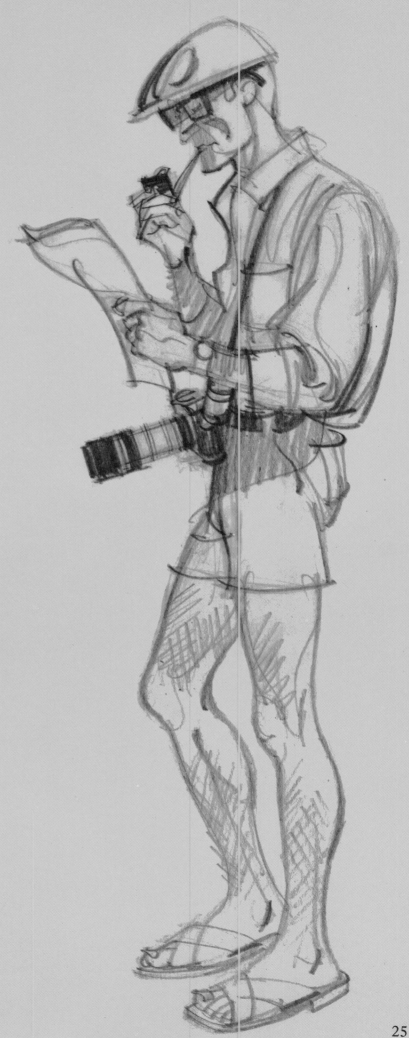

Look at the finished version of the sketch we have made. The characteristics are the same but this one is more studied, more complete as a drawing. However, it is still our tourist in the park. We could never have done this drawing in this way without observation from life.

Now we have plenty of time to complete our sketch; but we must do it on the spot. If we delay we shall lose our mental picture. Immediately afterwards, we unhurriedly recollect all the details we had not time to draw: the shadow of the cheekbones, the thin lips, the large glasses, the folds of the shirt, the map etc.

The final version

A sketch made on the spot is rarely the final version. Generally we complete the work started in the park or in the street when we get home. There, in peace, you can make a satisfactory drawing based on your sketch.

You should remember above all that the final drawing need not necessarily be an exact portrait of the subject you are redrawing. Since you are the only person involved, no one is going to dispute the likeness of the face and the cut of the shorts. This fact gives you a certain licence which you can turn to good account.

However, if you change the original subject too much you will have borne the heat of the August sun on that park bench to no purpose.

Finally, you should do a certain amount of elaboration, that is improve on the original sketch but without sacrificing the freshness that only observation from life can give.

25

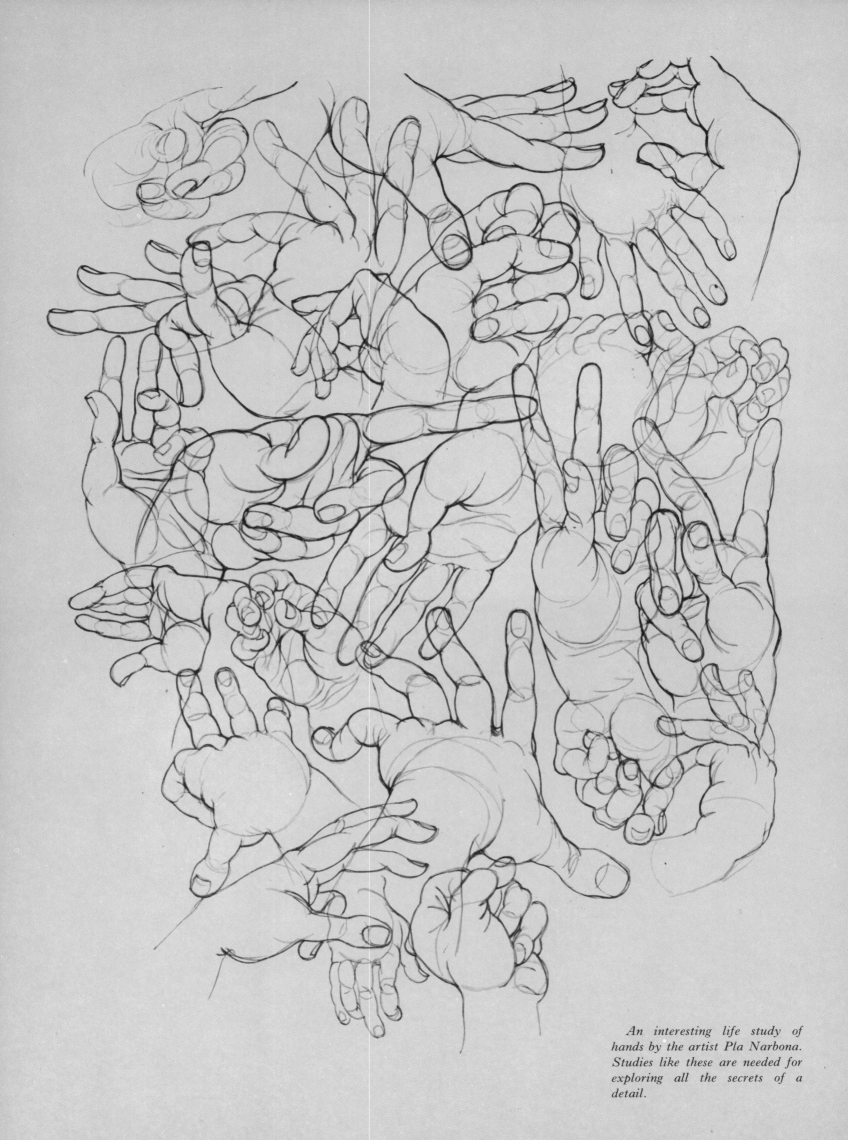

An interesting life study of hands by the artist Pla Narbona. Studies like these are needed for exploring all the secrets of a detail.

SYNTHESIS

Synthesis involves reducing a subject to its essence and is therefore a simplification. An ideogram of a man, the child's matchstick man, is an elementary example. Every truly artistic creation must be preceded by some process of synthesis. A form can only be interpreted after the basic lines are discovered. Synthesizing, however, does not mean achieving a result in four strokes of the pencil. These four lines must be right. Many (too many) produce drawings or sculptures unfinished or faultily constructed in the belief that such work becomes thereby modern and highly artistic. Wrong! The synthesis is in fact the **ultimate refinement of the form.** It implies the maximum knowledge of a subject. Its simplicity, its 'four lines' are the fruit of study, whereas aimless simplicity is the fruit of laziness.

You can see on the right how a synthesis comes about. Starting from a subject in life, the artist has eliminated all the unessential parts. But, despite the complete absence of details, the township remains a township. However, this is an elementary synthesis. Synthesis offers a wide potential field of which the ultimate limit is abstraction.

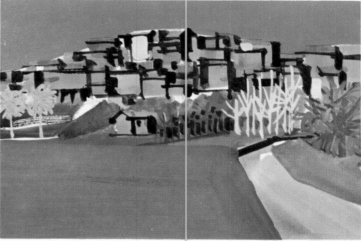

You can see, below, an exercise in three-dimensional synthesization. The model is a simple natural form, an almond. Two students have produced different interpretations of it, but both have extracted its intrinsic beauty.

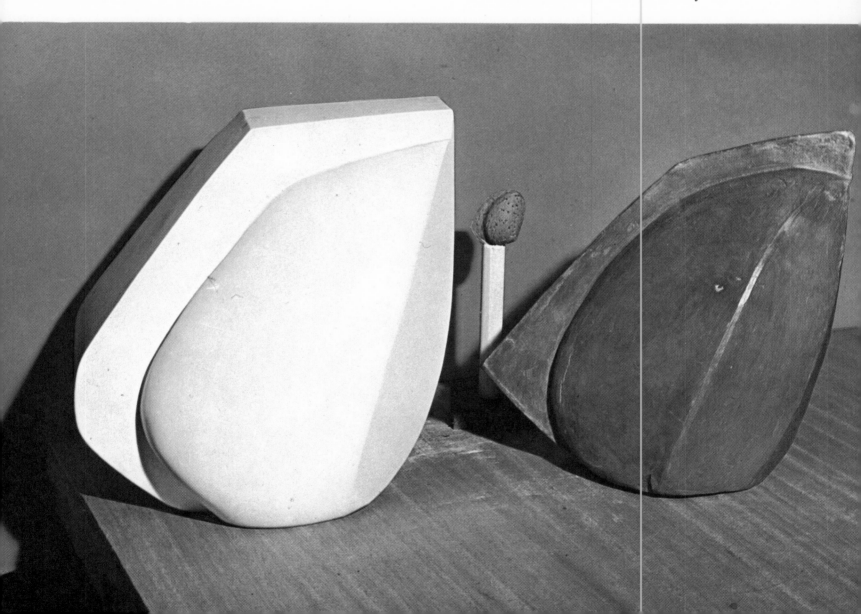

The examples on these pages are the work of art students at the Massana School in Barcelona, where the admission to an advanced course is decided on their ability to synthesize. In this school they rightly claim that the student who is incapable of synthesizing will find it difficult to pursue the path of art.

First, look at the three interpretations of a tree, widely divergent but all attractive. The first is the simplest and exploits the strange density of the tree. The second concentrates on the foliage. The third and most realistic emphasizes the beauty of the branches and the fresh colour of the leaves. As you look at these studies, do you not feel convinced that you yourself could produce scores of similar variations?

Now glance below at three progressive phases in the synthesis of one subject. The first hand is almost realistic. Only the accurate execution, the softness of the colouring and the placing imply a selective criterion. The second is interpreted more freely in form and colour, likewise the ear of corn. However, the most successful is the third; the selection is total, the form has been controlled down to the smallest detail. Even the original colours have disappeared to give more strength to the golden ear. Now you try repeating the same subject several times and you will perceive, almost without realizing why, how the final version is better and simpler.

The synthesis applies to all media and techniques since it is a way of seeing and feeling. Not one but many techniques, because of their limited resources or because the results are more pleasing, are applied on the synthesis principle. Once you learn to synthesize you can apply the principle to all your work. The result will be interesting and of genuine artistic merit.

This applies to the locomotive on the right. It is a mural decoration executed with cement on which the design was formed with applications of dark sand, resistant to the ravages of time and weather. This synthesis has been purposely distorted and to excellent effect. The simplicity of the subject has been adapted to the technique employed which does not allow small details nor variety of colour.

Low-reliefs, by their very nature, favour simple subjects and well-defined lines which permit of clear-cut incisions. In the absence of colour and volume, everything is left to the relief. Hence the need for perfect stylization.

The final two examples shown below are masterpieces of selection of form and of technical execution. The plaster of Paris has been treated with the care that this brittle material requires. One mistake and it cracks; a false chip and the whole thing is ruined.

The works on these pages are reproduced from students' exercises at the Massana Art School, Barcelona.

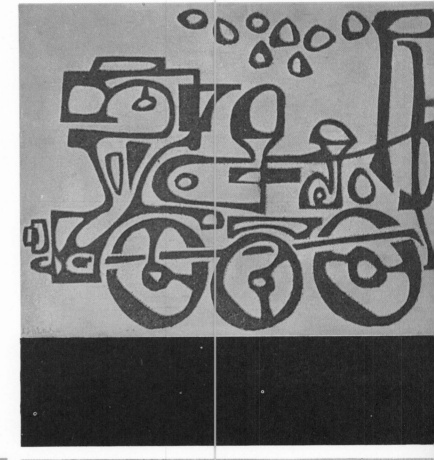

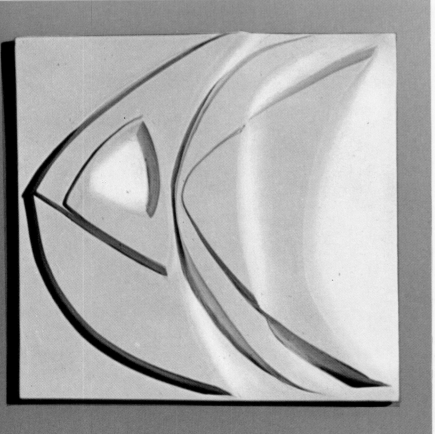

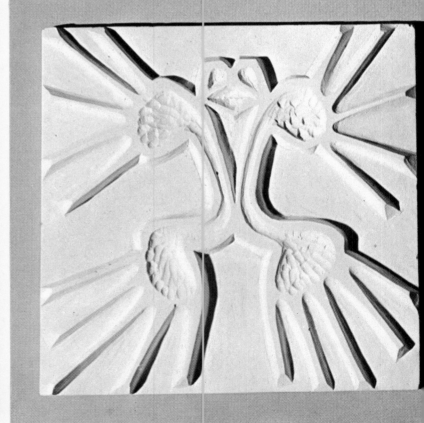

SYNTHESIS OF THE FACE

The face also gives scope for the process of synthesis which underlines its expressive power, originality and character. Do not however confuse a stylized face with a caricature, although both may have points in common.

To stylize or synthesize in this context implies putting an emphasis on physical and expressive aspects of the model to bring out its character more effectively. We are faced with a more complex problem than that of the almond. The problem there was just its form whereas with the human face there is the question of character, emotion and expression.

From the point of view of basic form every normal human being is the same. From these constants—the two eyes, two ears, a mouth etc. the artist must build up a **personality.** By means of synthesis he individualizes physical nuances which determine the intimate personality of each subject.

Caricature, too, is indeed a product of synthesis but executed for humorous or satirical purposes. Features are exaggerated to the nth degree, without regard to aesthetic considerations. The artist is solely preoccupied with the character or humorous aspect of his subject. Nevertheless, caricature can be raised to a fine art, as we see for example in the work of Rowlandson, Gillray, Daumier and Max Beerbohm.

You should learn therefore to study people, to distinguish their small physical differences. Only thus can you profit by the present experiments and reproduce psychological insight in your portraits.

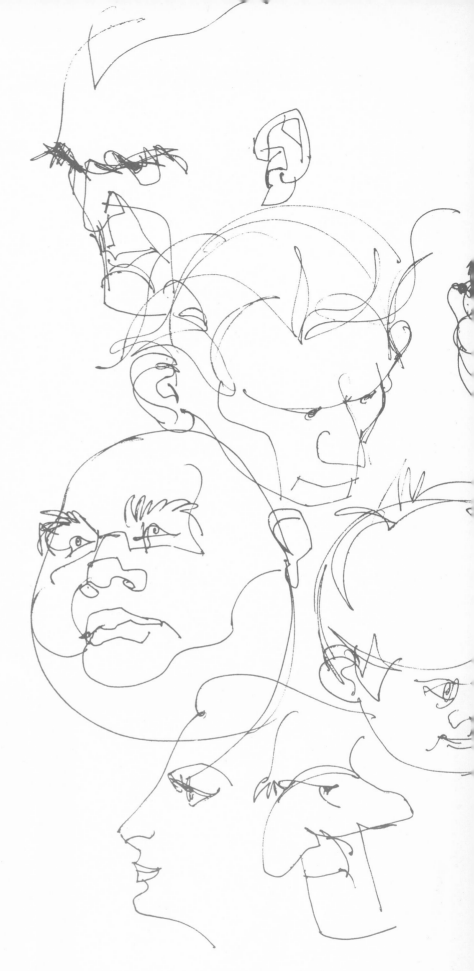

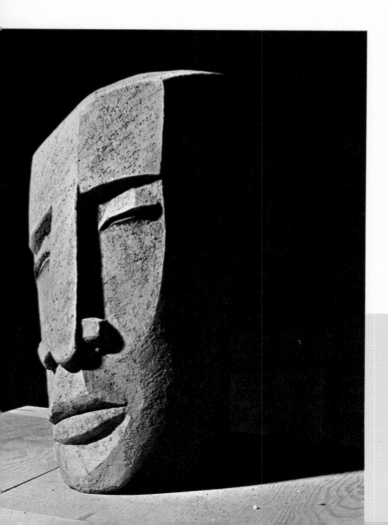

Note the carving shown on the left. This face has been sculptured in a pure spirit of synthesis. The features are certainly exaggerated but are far removed from satire. Indeed, his expression is rather tragic and reflects the psychological insight on the sculptor's part. Aesthetically the execution is unexceptionable.

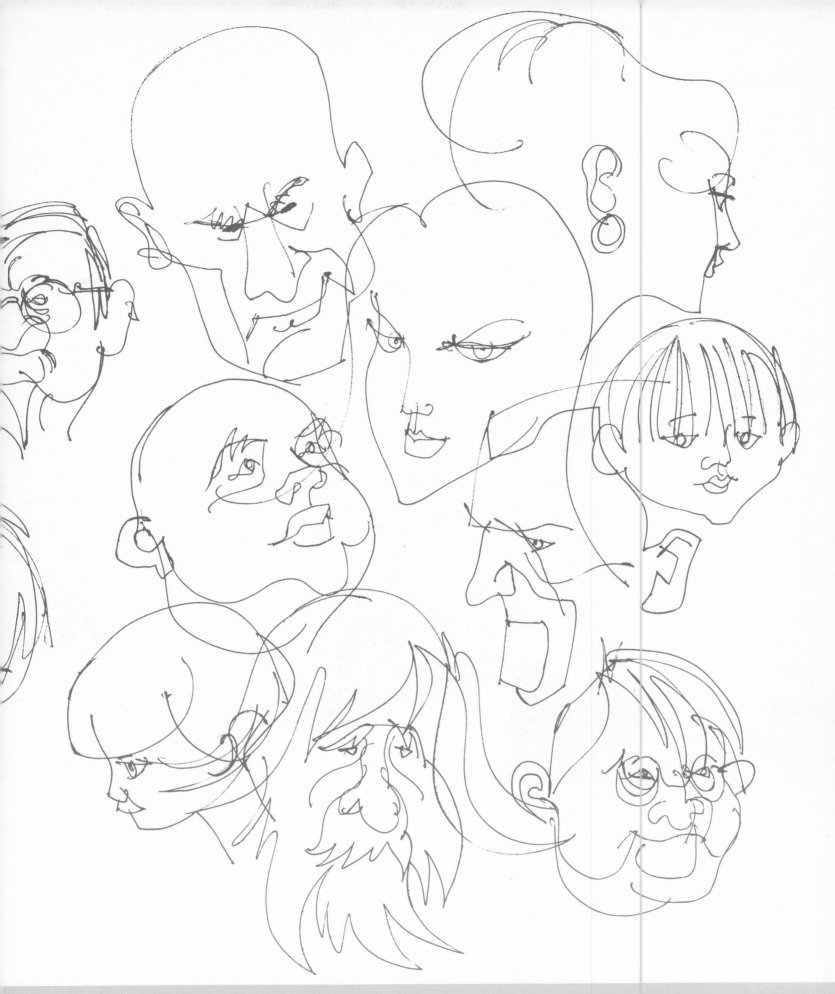

Now look at an original sample of various facial types. These sketches are on the border between expressive exaggeration and caricature. Basically they are neither, but merely a kind of artistic gymnastics, almost a calligraphy of the face by someone who, after careful study in the past, has learned to extract its full potentiality almost without lifting pen from paper.

Only after gaining complete mastery of the anatomy of the face can you play in this way with its basic lines. At first sight it seems an easy exercise but try it and you will see how deceptive this simplicity can be and how every line is essential. By continual practice of drawing from life you can gain this ability yourself.

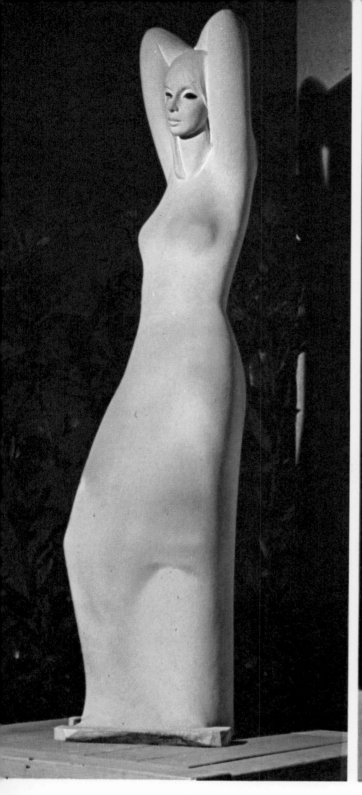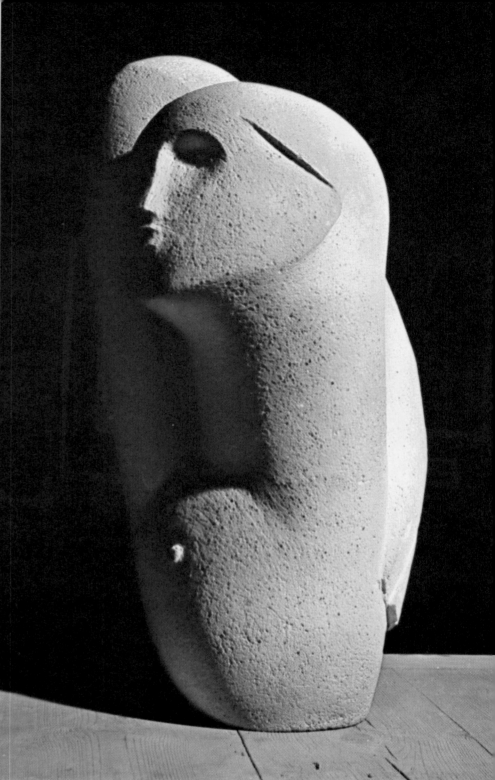

Sculpture lends itself particularly well to synthesis. Perhaps because the form takes shape slowly or because the sense of volume and movement is more direct, sculpture emphasizes harmony and movement rather than details. The material (stone, marble, clay etc.) gives variety and interest to blank surfaces and allows of greater simplification of forms.

On this page you see two very different treatments of a very similar subject. Both have been carried out in a spirit of synthesis. A glance at the first may make you think that the apparent realism of the figure was not achieved in this way. This is a point we should clarify; synthesis does not necessarily imply distortion. It can mean **selection,**

simplification of line, stylization of forms. This sculpture is realistic in pose and proportions but form and line have been stylized to the maximum, consonant with the amount of realism required.

The second sculpture belongs to a different, bolder style. The exaggerations are made for plastic objectives which reveal the artist's personality and imagination. In this process the distortion of the subject, far from inviting laughter, is highly expressive.

This then is the difference between the two works: the first has been elegantly stylized, whereas the aim behind the second has been expressivity.

Practice in synthesis

Synthesis is the foundation of art, and it is essential to grasp its paramount importance. It may appear to some that this process is no more important than perspective, composition, light and shadow . . . but no other lesson is as fundamental.

The process does not mean leaving your drawings incomplete or in a sketch state but **individualizing the essential forms of a given subject.** This is not to say that there is only one way of synthesizing a subject in the way one solves a mathematical problem. The solutions are infinite —as many as there are artists. One thing, however, will be common to all: **the representation of the essence of the subject.**

On this page are three subjects for you to synthesize. Each student should analyze the subject, eliminate the unessentials and produce his own simplification. You will be surprised to see how differently each individual sees things. But, above all, do not copy the reality nor embark on the work without a previous analysis. Synthesis demands method, study and a few wasted sheets of paper.

The sea-snail *offers these characteristics:*
Irregular 'helicopter' shape, shell with a circular entrance and a long, thin tail.
The 'spines' which surround the snail are long and harmonious, inviting exaggeration.
The most characteristic feature is the spiral form of the crustacean's shell.

The industrial complex *suggests:*
Various vertical cylindrical elements.
Vertical towers of iron frameworks.
Various platforms. Circular or square according to their position in the cylindrical towers or in the cube-shaped one.
Parallel pipes on the first storey.
The essential feature: the cylindrical towers with the asymmetrical disposition of the platforms.

In the portrait *we can observe:*
The expressive strength of the hand.
The shadows on the face (particularly under the eye socket).
The main feature is the play of light and shadow, sufficient in itself, even without further details, to identify the subject in a synthesis.

Further investigation

At the present stage things will be easier. Making the initial effort is always difficult, but now you have made a start, widening your artistic capacity will only be a technical problem. This then is the ultimate test of your ability. If you have been thorough in your practice in this and in the other two *Alive to Art* books, you will now command sufficient skill and technique to carry out any work in the spirit not of how to do it but what to do.

By now you have enough practical experience and knowledge to undertake more advanced techniques and processes, not so much for their own sake as for the perfection they require. This investigation however will extend beyond techniques. It will include aspects of artistic appreciation indispensable for a proper knowledge of the subject. So, in the remaining part of this book, you will be examining new techniques. In the extension of those already introduced, you will learn various practical applications, and in the last few pages there is a section devoted to the history of art.

Special techniques

Take your scissors and paper to deal with a kind of art that is on the fringe of the more traditional activities.

After this experiment you will have gained enough confidence in your practical ability to undertake any handicraft. This is important. Many opportunities come along (not necessarily aesthetic) for putting such practical dexterity and good taste to the test.

Applied art

If art is the creating of beauty, it is obvious that we do not find it only shut away in museums or displayed in art galleries. Art is too great a force to be confined within such narrow limits. Wherever man is, there will be creation and where creation is there will be beauty. Art then will constantly break through the barriers of tradition and invade all human activities. This is why the craftsman and applied arts share an aesthetic responsibility which should not be underestimated.

Art education

Civilization is the result of the passing on of culture through the generations. Who knows what human progress would be like if man lacked the gift of self-expression.

Artistic culture, like any aspect of culture, is not only something with which we should be familiar but a thing of paramount importance which we must learn about if we want to enrich our lives. This way we do not need to toil along a path that the great ones of the past have already made for us.

Do not conclude however that the techniques you will be observing and that the outline history of painting with which this book closes are adequate to provide the study in depth which art requires. To this there is no end, since every technique suggests another, every comment on art, heard or read, opens new doors to one's understanding of art and artists. The kind of study in depth we mean implies perpetual curiosity and tireless practice.

SPECIAL TECHNIQUES

In the other two books of *Alive to Art* you are introduced to many techniques to do with colour and volume. There is no need to go over this ground, repeating the same principles. Nevertheless if you have already studied these books you will now find it interesting to assess the progress you have made in knowledge and skill. Have another look at all the techniques, pausing on those which demand special effort and concentration. Meantime let us make the acquaintance of a new one.

PAPER SCULPTURE

Since it is impossible to model or carve in the ordinary sense with paper, the only way to obtain a determined volume is by **rolling, folding** or **cutting** your prepared pattern.

Rolling is the main method of constructing the basic core of the 'sculpture'. In the examples illustrated on this page, you can see how the principle parts of the two subjects have been built up on a foundation of two cones of rolled-up paper, representing the bodies of the figures.

When you have decided on the central idea of the subject you want to make, the rest is a question of patience, skill and taste.

In every technique in which the result is partly conditioned by the materials, a degree of simplification (synthesis) is indispensable, since we have to represent all forms in terms of basic shapes.

On the next two pages you will find the patterns for folding the pieces necessary for making the two examples shown. You can trace these patterns, or measure them if you wish to adapt them or increase the scale. This kind of subject allows you to give free rein to your imagination. Any colouring should be done before the rolling, folding etc. so that the final result will be kept clean.

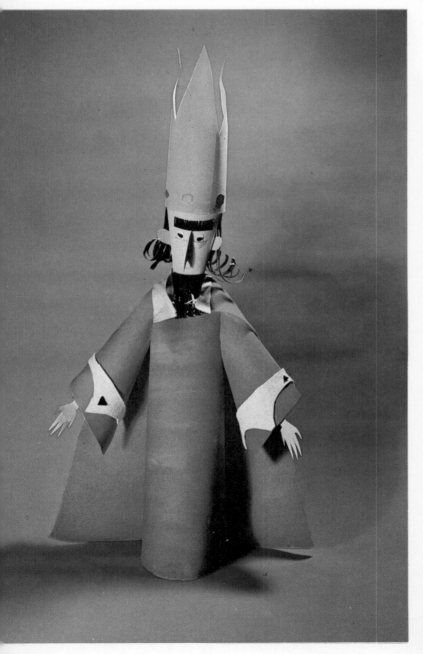

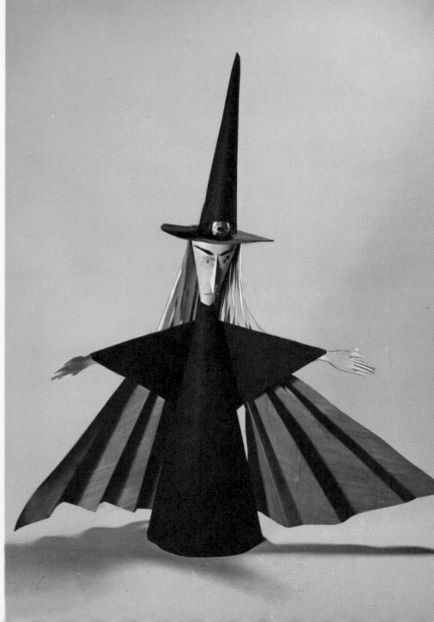

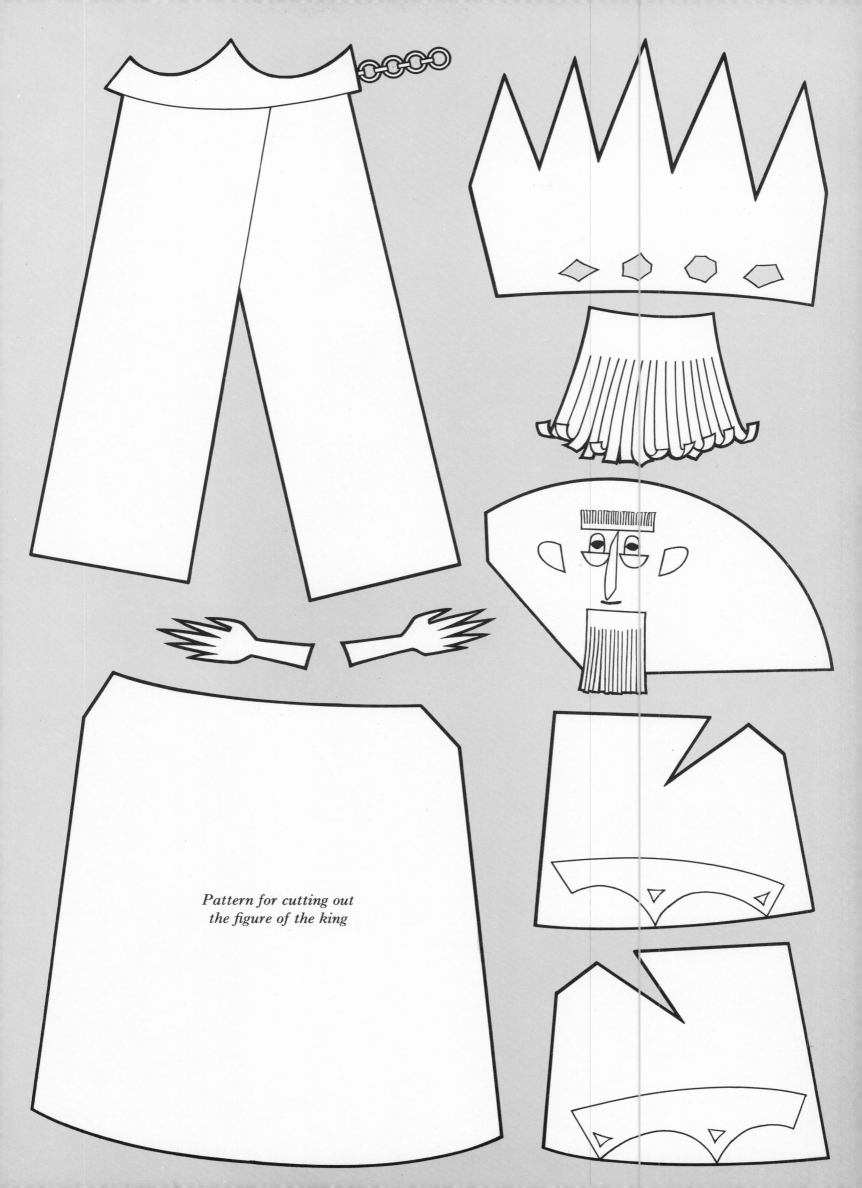

*Pattern for cutting out
the figure of the king*

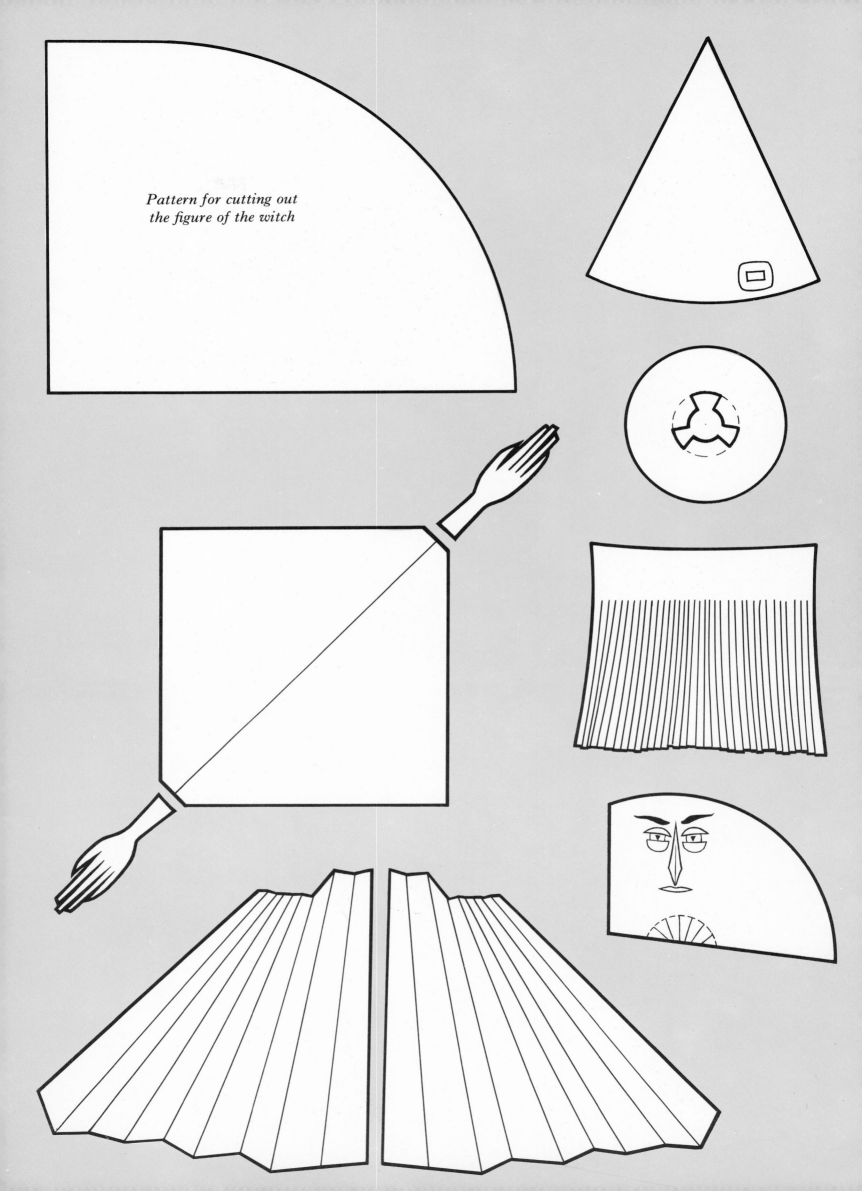

Pattern for cutting out the figure of the witch

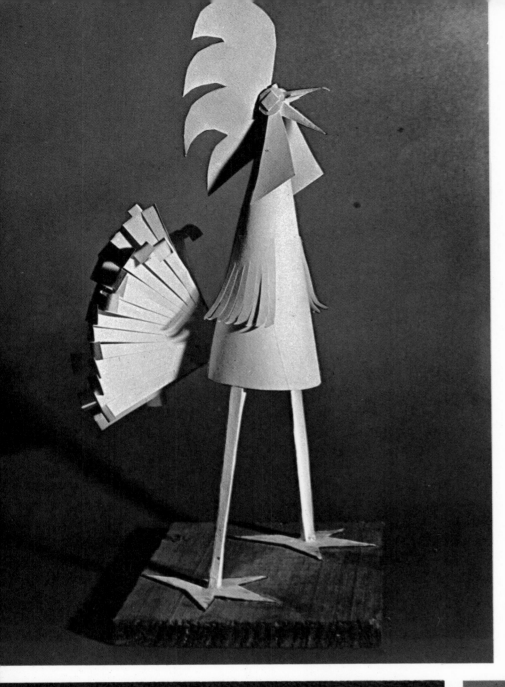

The examples shown are only a sample of the infinite possibilities with paper as a modelling material. You will easily find other subjects which you will be able to make without too much difficulty. Merely apply the technique explained. Each person, starting out from the same technique and identical subject will discover his own individual solution. Look at the three examples on this page made by three different students on the same theme of the cockerel. Note, that despite the respective difference of approach, all three are most attractive. These examples will teach you more clearly than a lot of instructions about the possibilities of paper sculpture, provided you start out with a clear notion of what you want to make.

Scissors are the main tool for decorating paper sculpture. You can not only give a shape to the various parts of the subject, but, experimenting with detail cuts, you can add genuinely decorative effects.

A final hint: be very careful with the paste or whatever adhesive you use. Any messiness can spoil the whole result, so be sparing with the applications. Now go ahead.

Massana Art School, students' work

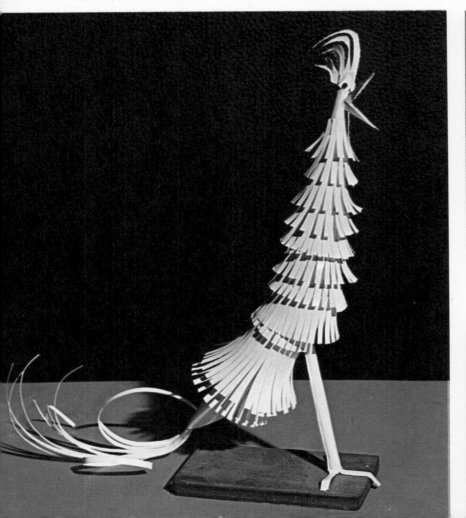

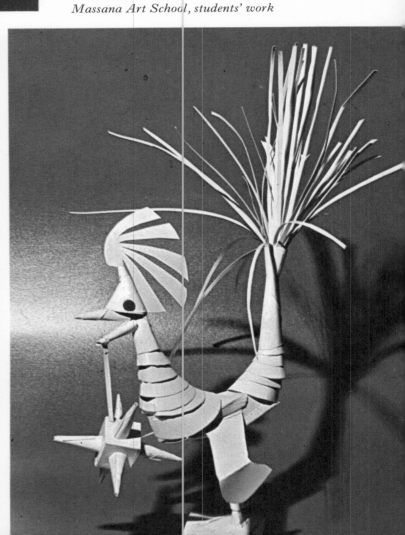

Low-relief with paper

Using the same materials you can make low-reliefs on similar lines. Perhaps low-reliefs are even more suited to this technique and less difficult to carry out than sculpture in paper. On account of the relative simplicity of their shapes, however, they need more imagination.

As a creative starting-point you can avail yourself of abstract and repeat designs such as those illustrated on these pages. You may well think that subjects of this kind are difficult to make. Don't worry, to some extent trust to luck! Fold and cut strips of paper of various shapes. Try all sorts of experiments and be on the look out for **interesting shapes.** Study them carefully and work out the technical means for producing repeat patterns.

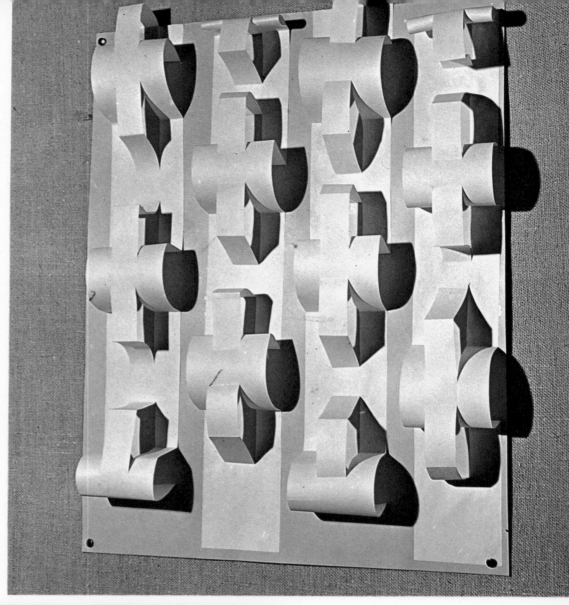

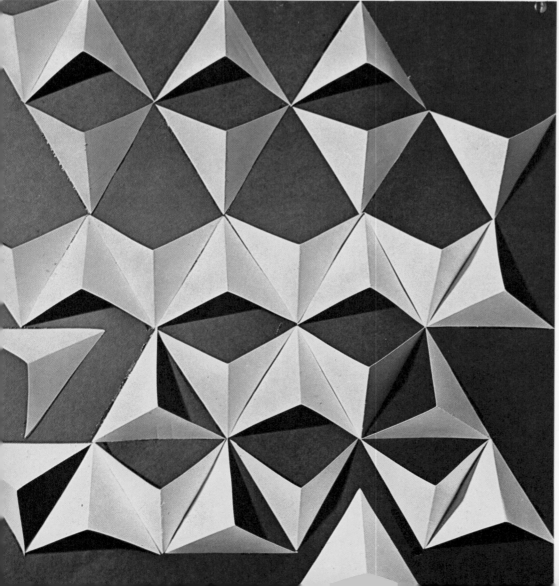

Success in this kind of work often lies in the preliminary study for obtaining your result. This consists of measuring the units involved, arranging them on the support, considering methods of fixing, background colour etc. You may not be successful at first, but at every attempt you will get closer to your idea until finally you obtain an attractive result. Another look at the two low-reliefs reproduced will encourage you to invent something yourself on similar lines.

COLLAGE

Collage is the application of coloured paper on a background 'support', a technique you were introduced to in the other two books of this series. This time however we shall not do the collage with paper but with other materials. The attraction of collage lies in the choice of the material for sticking. Any materials can be stuck down—cloth, grass, objects, sand etc. One has an infinite range of expression and results are rewarding.

On this page are three original examples carried out with various materials. However, as you see, technique is not enough to make these interesting works. The subjects too must be suited to the technique, and, above all, they must be attractive and original. Only thus can you realize its full expressive potential. Furthermore technique dictates the subjects, and you must keep this fact in mind as you evolve them. Remember that a well-planned and attractive result is the fruit of a successful combination of subject and technique.

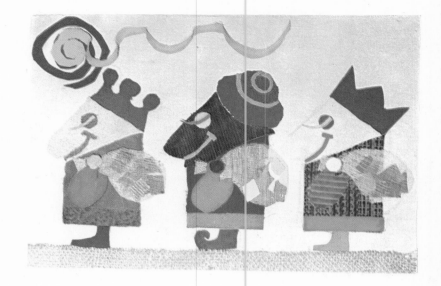

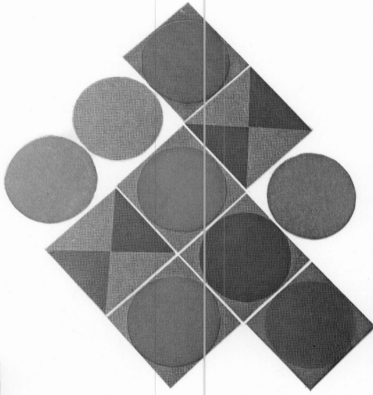

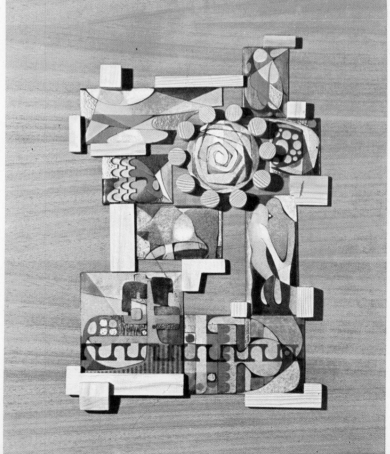

In the first subject, The Three Magi, *the collage was made with pieces of cloth. The varied nature of the material adds great attraction to the subject.*

The second, Geometrical Composition, *was made with wafer-thin slices of cork, but the colour and texture are very different.*

The third example, Decorative Panel, *is handsome, but made with fragments of decorative ceramics and pieces of wood fixed on to a panel; it involved more advanced technique.*

Massana Art School, students' work

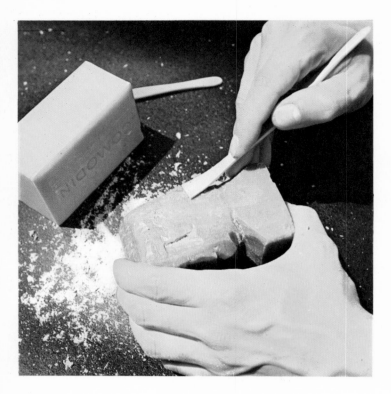

New techniques

It is always rash to call any art technique 'original'. Artists are continually seeking out new forms of expression and we hardly find it odd when the same artistic solution occurs in the works of two artists who do not even know each other and in two widely separated places. However, we will take the risk, trusting that for you at any rate these techniques are new.

SCULPTURE IN SOAP

This heading may make you smile, but you cannot imagine the number of possibilities this technique offers because of its workability and the attractiveness of the results. Soap is soft, clear, agreeable to the touch, slightly translucent, and the colours of amber, cream, greenish, ivory, have a strange mellow appearance.

Out of all these properties, the most important is its softness. With a chisel and knife you will have no difficulty in carving a bar of soap. You can, moreover, obtain results which look deceptively like nobler and more exotic materials.

As you see from the examples reproduced, soap lends itself to any subject: simple forms exploring the material, symbolic forms accurately executed, animals (note the successful syntheses) and even the human face. The colour of the soap is chosen according to the subject.

It is impossible to explain in a brief space the process of synthesis for each group of the subjects shown. Study them carefully and you will grasp the spirit behind them. For your own work, bear in mind what you have already learned concerning the simplification of forms. Do not try to copy the

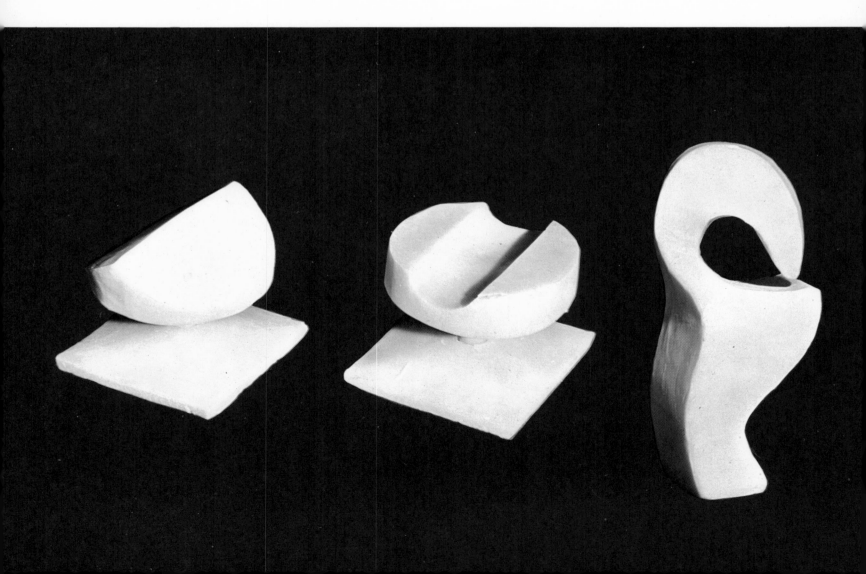

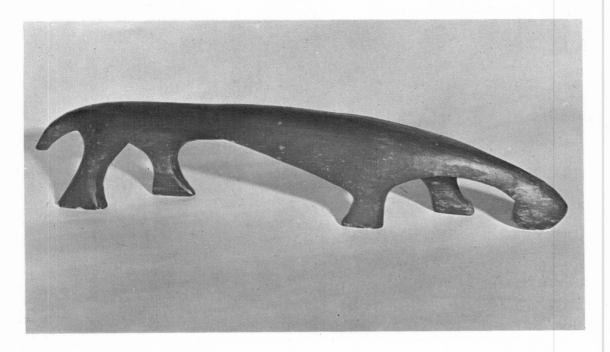

subject. Pay attention rather to the basic forms that compose it and—trust to your fingers! Do not feel that everything has to have a meaning. Concentrate instead on the three-dimensional attractiveness of your subject and how to realize this. Only in this way will you produce original and interesting results.

In this connection it is worth mentioning that a certain soft stone, called 'soapstone' is widely used in many parts of the world (especially for the carving of small objects). It is however hardly a noble sculptural material, say, compared with marble etc. Ease of carving is not the sole consideration; a very soft stone creates problems[1] no less than very tough stone such as granite. The former is too little resistant to the chisel and crumbles when subjected to weather, the latter is too hard and coarse. Occasionally—almost a *tour de force*—we find miraculously fine carving done on granite, for example at Launceston church in Cornwall. Soft stone, like alabaster, is reserved for interior church monuments.

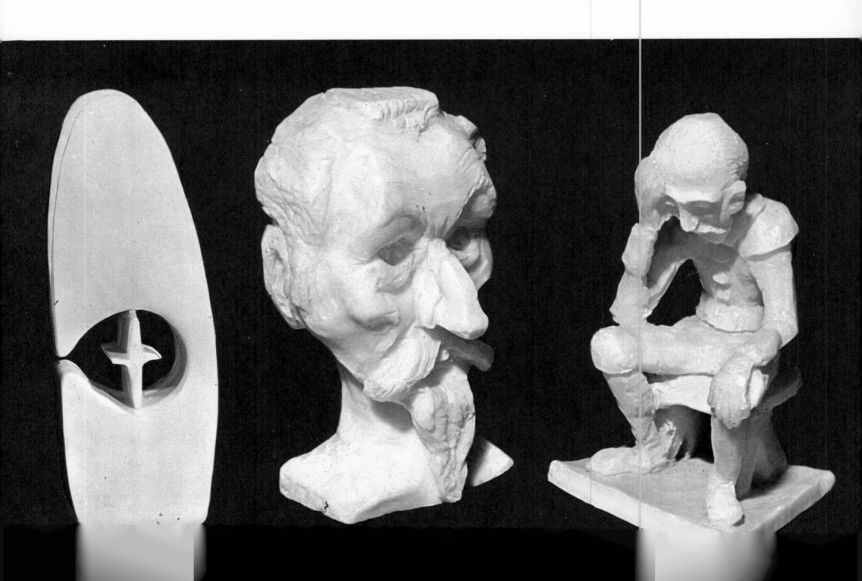

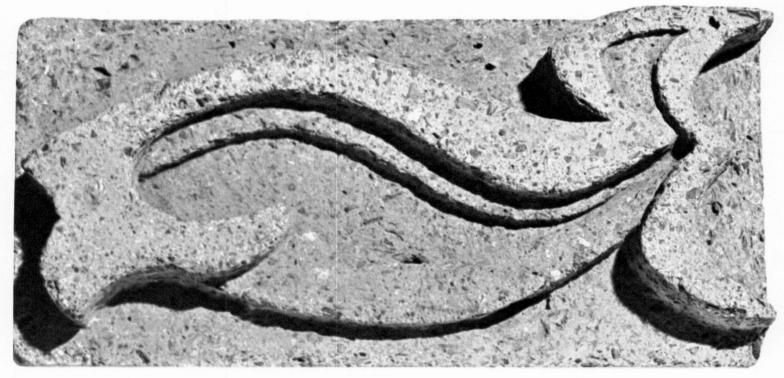

Massana Art School, students' work

LOW-RELIEF CARVING

Here is another interesting and in-expensive technique. Go to a builders' merchant and ask for a light-weight concrete block called Lignacite. You will find that this is sold in varying thicknesses so decide on your subject first.

Draw the image on the surface and start carving. You will become aware that the material is fairly easy to work and is capable of original and effective results, but choose a simple subject since the concrete is not suited to subtle details.

Other materials you may like to experiment with are ordinary bricks, or aerated precast stones such as Romanite and Thermalite. They do, however, tend to be rather brittle.

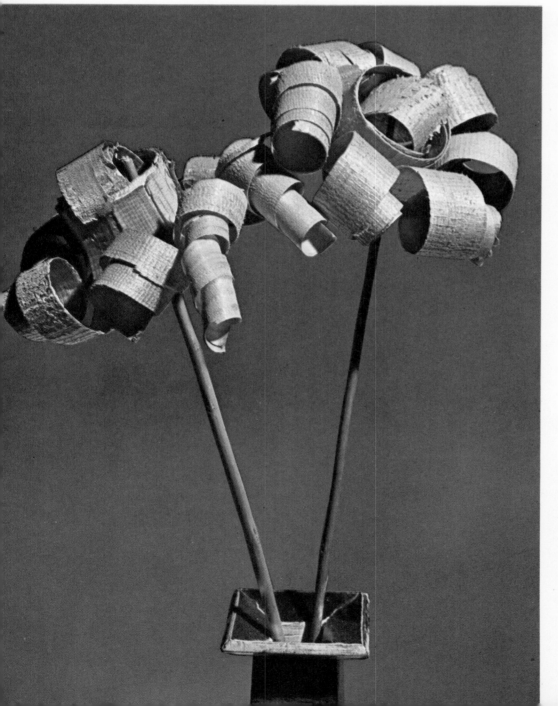

WOOD-SHAVINGS

We will wind up this survey of original or at any rate lesser known techniques by seeing what attractive results can emerge even from the use of a waste material like wood-shavings. The secret is to exploit the particular qualities of any material. In the present case, the curly nature of the shavings lends itself to these two interesting flower shapes. Any carpenter will supply you with as many shavings as you want. Try out your own experiments.

APPLIED ART

When we talk about art we mean 'fine art', the art that is concerned only with our free expression and the contemplation and enjoyment of that of others. Sometimes art of this kind gives place to practical more or less professional applications which come under the heading of crafts. We do not propose to go into the merits of arts and crafts, but it is worth while experimenting with some techniques which —without belonging to 'official' crafts—cross the border of fine arts. A study of these will form a basis for practical applications on your part. In these new experiments however you will have to supplement your aesthetic sense and your imagination with two new qualities: **skill** and **craftsmanship.** The technical execution of your work will be more exacting and prolonged, occasionally more exasperating than usual. But if you work with enthusiasm your efforts will be rewarded.

THE TECHNIQUE OF PAPIER-MACHE

Doubtless you must have seen various figures, caricatures of people and animals on certain TV programmes. Many of these are modelled in papier-mâché. Since papier-mâché is light but strong, it is the ideal material for your larger creations. It will also be a way of learning a technique which will be useful for a host of other projects. The materials required are readily accessible: newspaper, paste, plaster of Paris and clay.

As a handicraft this technique is very instructive with its five very different stages which will exercise all your talents:

Sculptural
Moulding
Elaboration
Painting
Decoration

The practice of this technique will increase the interest of your products and the various phases that arise from the complexity of the detail will surprise you.

Basically papier-mâché consists merely of strips of paper, pasted in layers on to the inside of a plaster mould. As the former dry they become solid and resistant and reproduce all the shapes and curves of the mould.

Now watch the successive stages in this work carried out for you so that each step is clear enough to enable you to attempt the experiment yourself. An oriental mask with its exotic and fantastic form seemed ideally suited to this technique. One of the

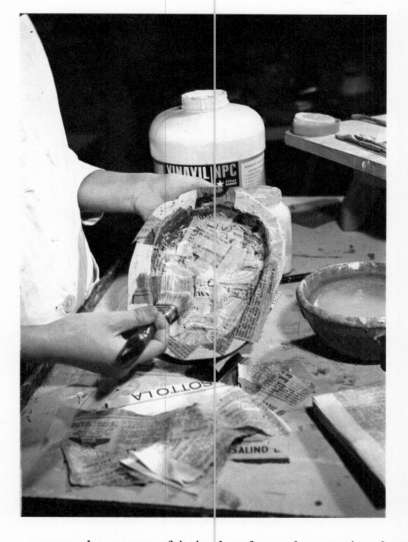

great advantages of it is that from the matrix of plaster you can make as many similar papier-mâché masks as you like. Let us now move on to the various stages of the work:

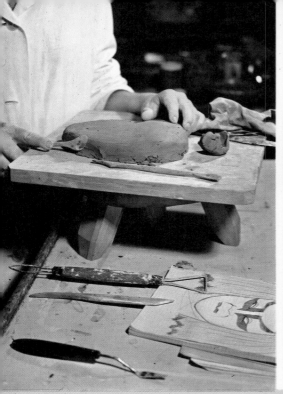
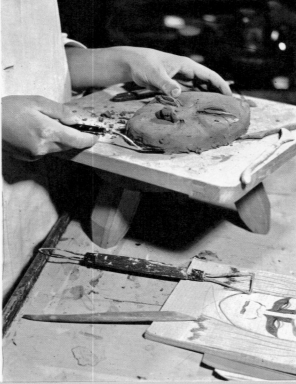
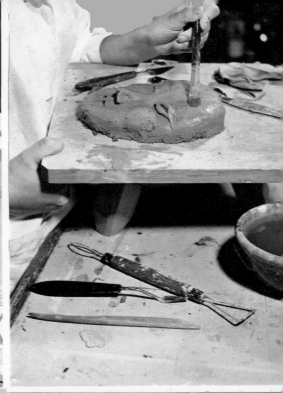

Above all you must have an exact idea of what you want to do. It is advisable to make a sketch and keep it in front of you throughout the whole process. Once the subject is chosen and sketched out the first stage begins:

Sculptural phase

1. *Take a board and on it with modelling clay prepare the amount required for the core of the mask.*

2. *To this add the details : nose, eyes, mouth—shaping them with modelling tools. Exaggerate the shapes and the relief since the small details tend to be lost during the papier-mâché stage.*

3. *The sculpture is finished. It now has to be prepared for the making of the mould. For this purpose, once it is dry, give it a coat of oil to avoid the plaster of the mould sticking to the clay matrix.*

Moulding phase

4. *We have now got the clay matrix of the mask we want to make. Next we prepare the plaster of Paris to make the mould. You need a receptacle containing water into which you empty handfuls of the plaster until you obtain a soft mass—not too liquid and not too stiff—for smearing over the clay.*

5. *Using a spoon proceed to cover the matrix with the plaster (to the depth of about an inch), making sure that every part of the clay is covered.*

6. *The layer of plaster must be thick enough not to crack when it is separated from the matrix. When this operation is completed, we give the plaster a convex and smooth surface with a spatula.*

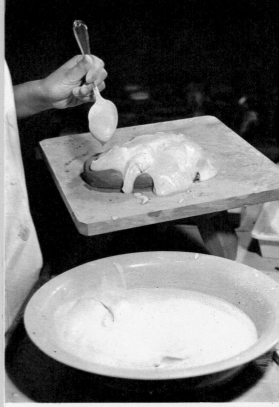
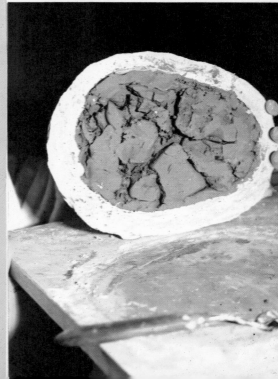

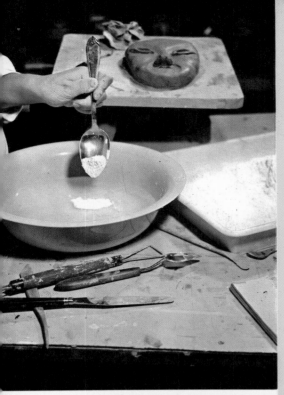

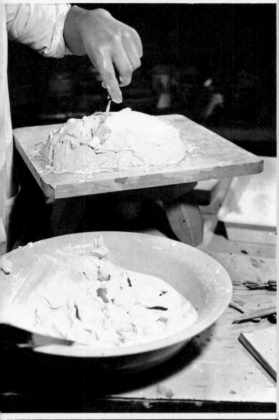

7. *Now, a short pause while the plaster dries. Then with the help of a knife or a spatula detach the whole thing—plaster and clay—in one piece from the board.*

8. *Mind you don't crack the plaster as you remove the clay from inside the mould so that the latter is completely empty and clean, ready to take the papier-mâché strips.*

Elaboration

9. *Here begins the papier-mâché technique. First make sure you have a supply of the material : strips of newspaper. These should be cut into small rectangular shapes, like those illustrated in the photograph. Prepare a good supply before you begin on the sticking process.*

10. *Having damped them with water, apply the first strips of paper to the inside of the mould, pressing them hard and making sure that they are long enough to overlap the edge of the mould.*

11. *When the first layer of strips has been applied—and these should be placed in all directions—we give the result a coat of paste and apply another layer, followed by paste, another layer and so on.*
Make sure that the pieces of paper adhere closely to the shape of the mould. This is not difficult ; paste or glue-soaked paper easily adheres.

12. *Once the various layers of paper are dry, we detach the whole solid mass from the mould. The margin of paper overlapping (stage 10) will ease this process. You must always make sure that the solid shape of papier-mâché emerges whole from the inside of the plaster mould.*

13. *Observe how the papier-mâché has taken on the exact form of the matrix. The mould is made. From this you can make as many copies as you want.*

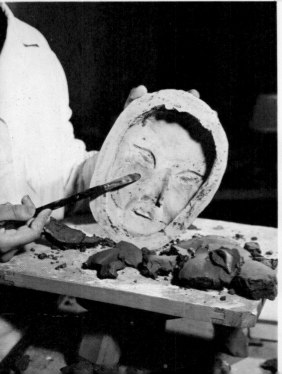

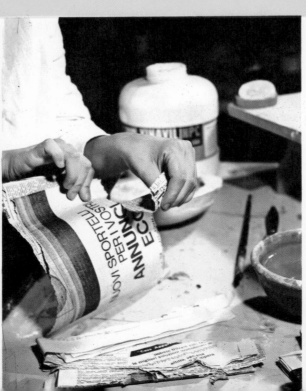

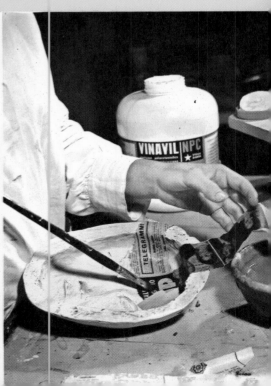

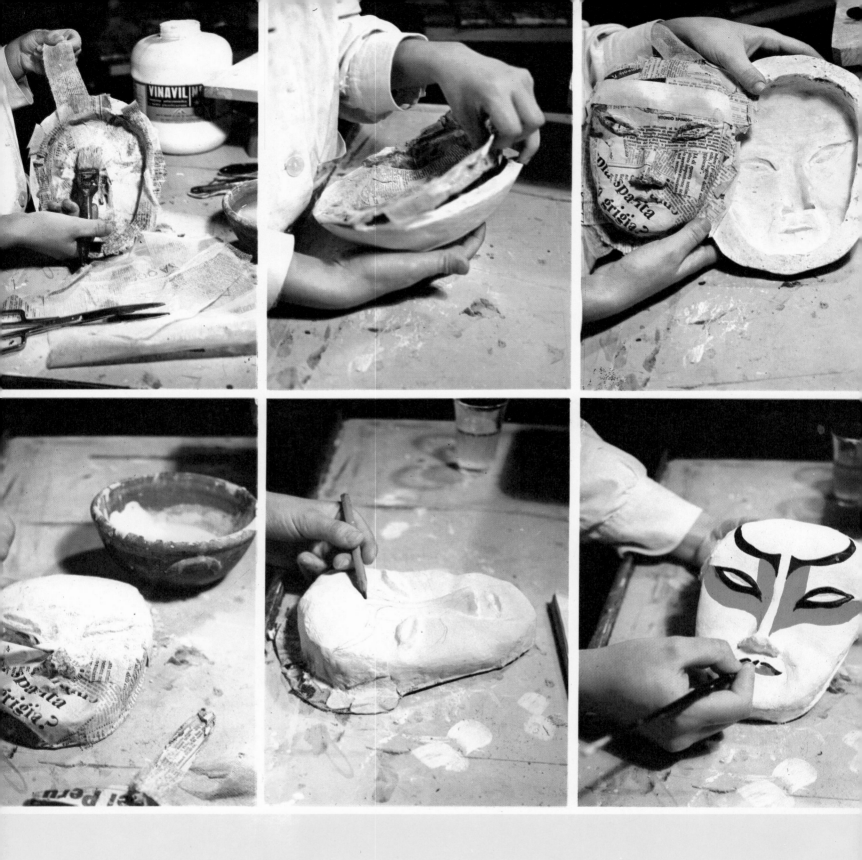

Painting

14. *Next we proceed to cut off the overlapping edges, leaving the mould of the mask clean and ready.*

15. *The newspaper print of course confuses the shape of the mask. We prepare therefore a small amount of liquid plaster of Paris (or white powder paint) and paint the papier-mâché white.*

16. *We now have a white mask. With our original sketch in front of us we can pencil in on the mask the details we require. Be careful not to spoil the work either by being too timid or by making the lines too black.*

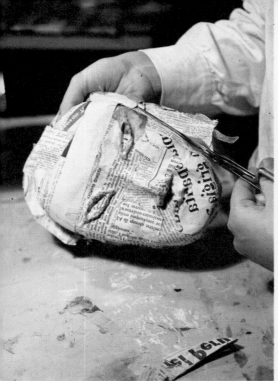

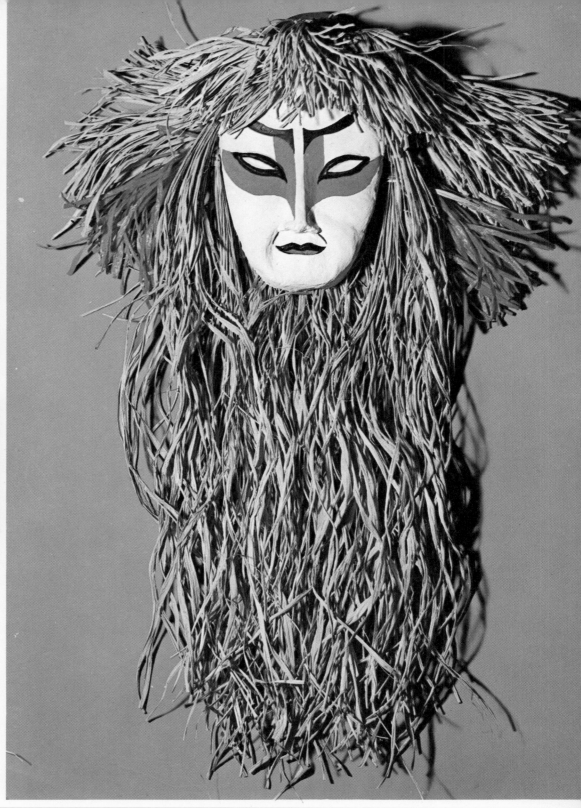

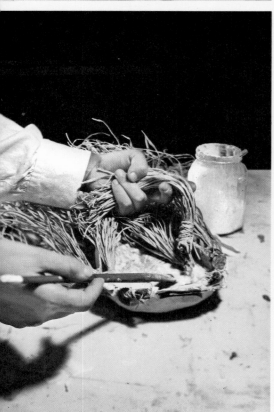

17. *The work is beginning to take shape. Now, with the help of powder colour we apply the details of the mask in the final form, according to the colours of our sketch.*

Decoration

18. *Only the final decoration is now lacking—the decisive touch to the work. Let us take some raffia and glue and binding material and apply some round the mask, taking account of the different lengths required for beard and hair.*

19. *As you see, the result is very decorative and successful. Within a few days you will probably be able to hang up a similar trophy on the wall of your own room.*

Group work

ARCHITECTURAL MODELLING

You may well be intrigued by those models which architects produce before embarking on a construction scheme of civic buildings, industrial complexes, public works etc. How perfect in every tiny detail despite the reduced scale! These models are, as it were, scientific toys which convey a surprising feeling of reality.

Such a model is not beyond your capacity, especially if you collaborate with others. As you progress together, you will learn to appreciate architecture from close to, study town-planning and at the same time improve your manual dexterity. Thus it can be a very complete experiment which will test your skill and taste and also prove a fascinating adventure.

The project

First we have to decide on a project. For instructive purposes we have chosen to make a **model of a holiday complex by the sea.** The area available is rectangular in shape and has its own beach. Given these factors you can combine with your friends and determine what the **features** of the estate are to be. It will be up to each participant

to express his or her own opinion in a logical and methodical way. Where there is a difference of point of view, you can take a vote. In the present project we presupposed the following conditions:

The production of houses to suit all tastes, single- or two-storied, and a multi-storied block of flats.

Tall buildings near the beach are ruled out because they would obstruct the view of the sea from those in the hinterland. The multi-storied building therefore must be at the maximum possible distance from the sea.

As it is a holiday place, sports fields and a swimming-pool are to be provided.

It is essential that every house should have proper access to the rest of the complex by means of adequate roads.

A marina for sailing etc. would be an additional attraction.

Parking areas, lighting etc. to be sited and shown.

When you make your decisions, perhaps by vote, on these questions, you should proceed to make a plan which will serve as a guide throughout the work of modelling.

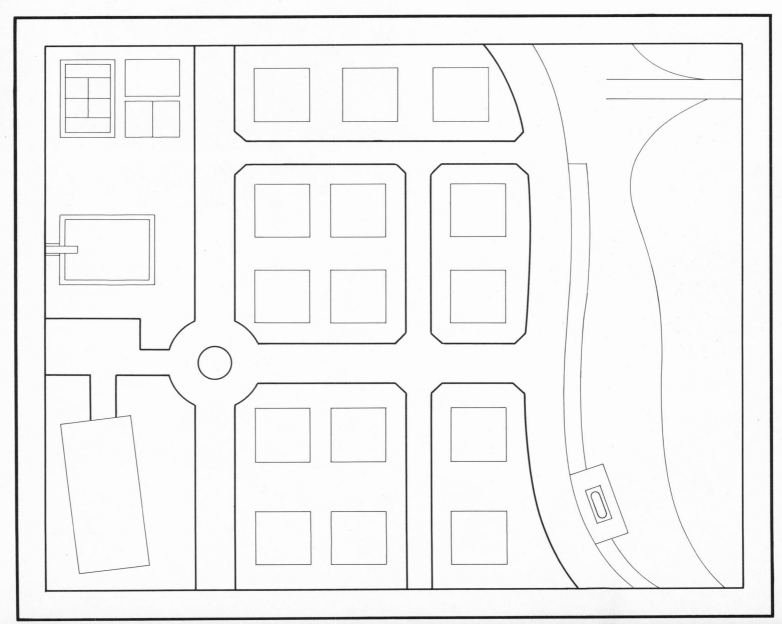

Distribution of the work

Since a housing estate is composed of residential buildings, it is obvious that the principal stage of this project is the production of these. Each individual will design his own villa, that is in accordance with the specifications of area, proportion etc. decided on. Within the agreed architectural features, you are free to carry out your own model. For the major construction of the block of flats, two or three individuals could combine. At the same time others could collaborate in the preparing of the setting on which the various houses etc. are to be sited.

On this page are the specimen buildings we have chosen for demonstrating a similar project. The first represents a bungalow, the second a two-storied house and the third a block of flats. These models were made of white cardboard, subsequently painted with powder-colour. They are trial models, made prior to the construction of the rest. As you see, you do not need to show details (doors, windows etc.) unless you want to include them. Careful modelling and due attention to proportion suffice to create the illusion of reality. You can use toys for the cars and we have used natural grass for the setting. But other devices can substitute for trees etc. that do not upset the sense of scale, as used in professional, permanent models.

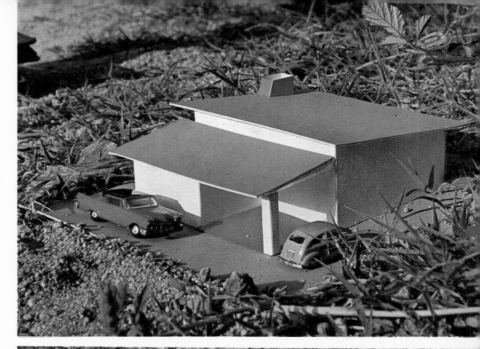

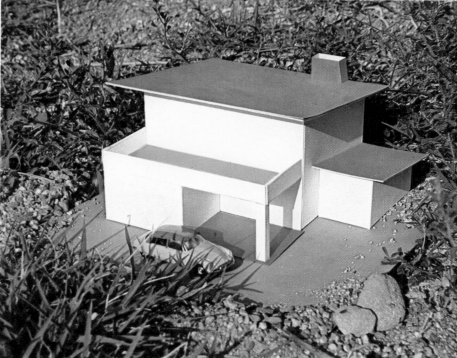

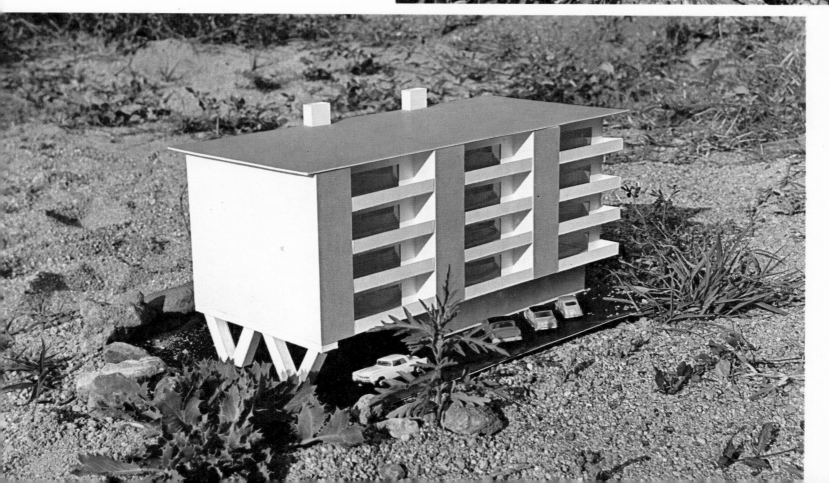

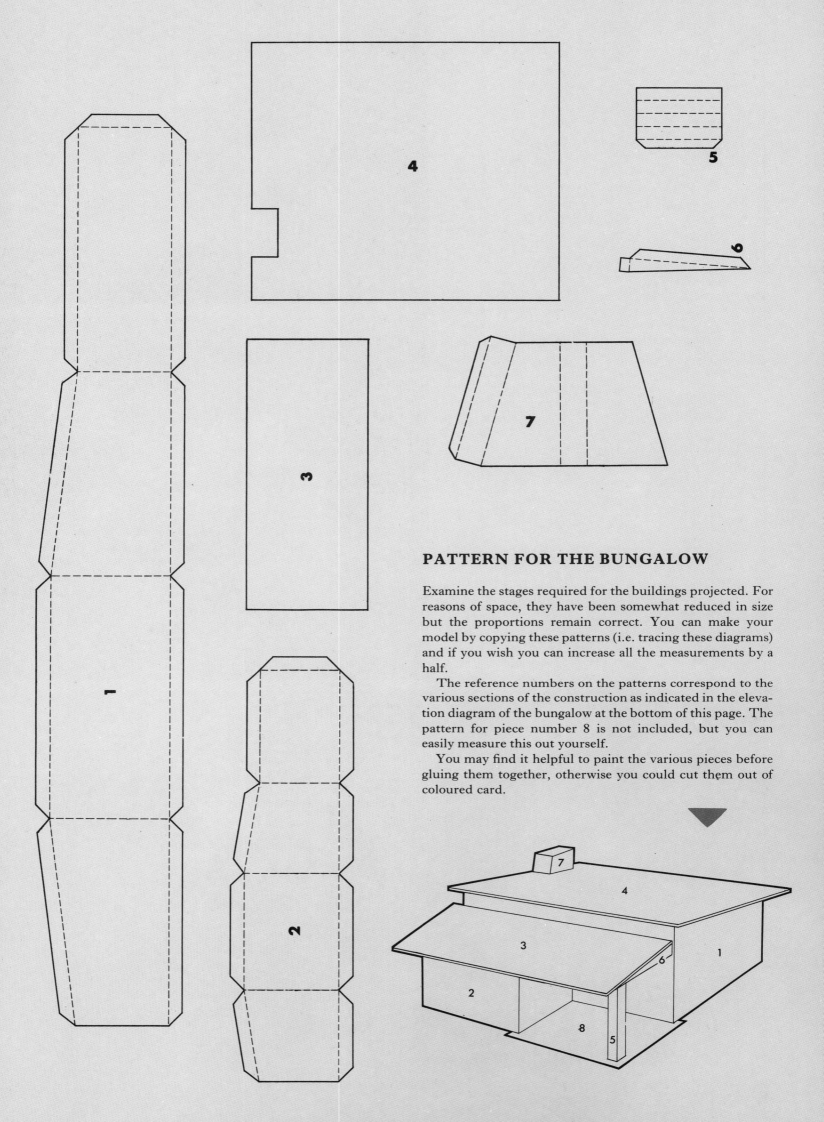

PATTERN FOR THE BUNGALOW

Examine the stages required for the buildings projected. For reasons of space, they have been somewhat reduced in size but the proportions remain correct. You can make your model by copying these patterns (i.e. tracing these diagrams) and if you wish you can increase all the measurements by a half.

The reference numbers on the patterns correspond to the various sections of the construction as indicated in the elevation diagram of the bungalow at the bottom of this page. The pattern for piece number 8 is not included, but you can easily measure this out yourself.

You may find it helpful to paint the various pieces before gluing them together, otherwise you could cut them out of coloured card.

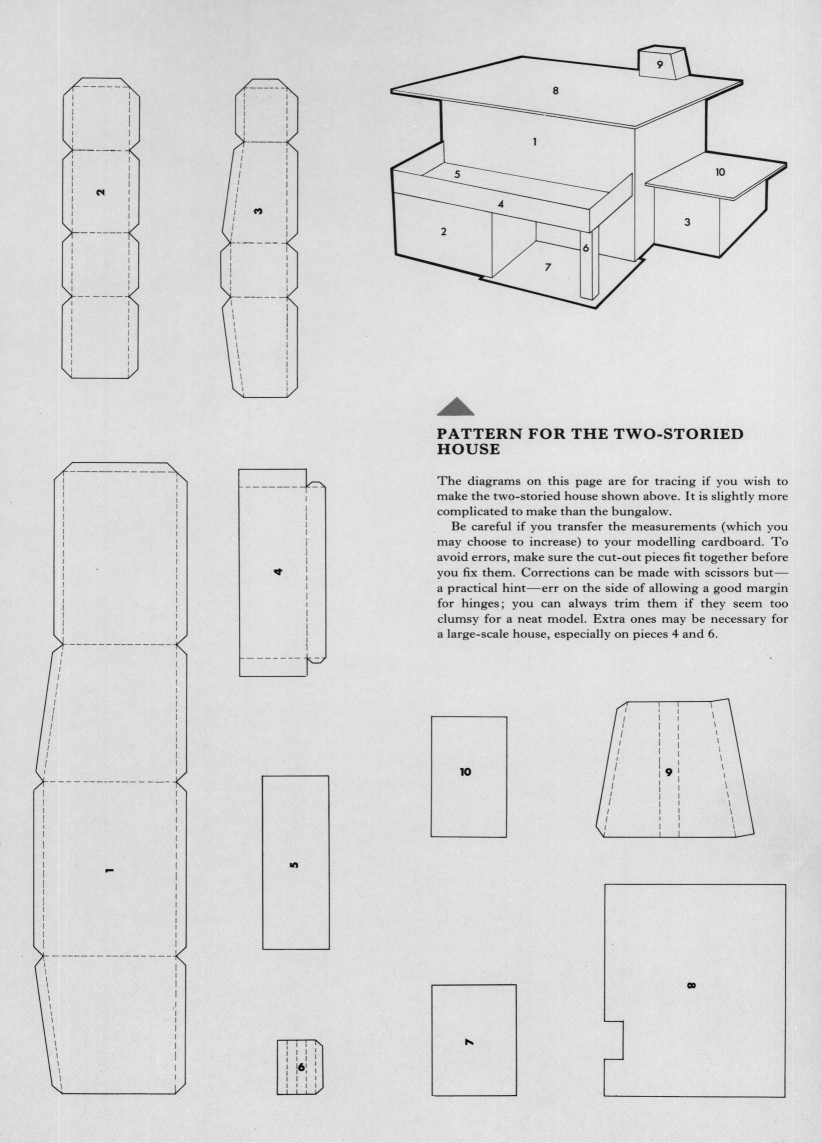

PATTERN FOR THE TWO-STORIED HOUSE

The diagrams on this page are for tracing if you wish to make the two-storied house shown above. It is slightly more complicated to make than the bungalow.

Be careful if you transfer the measurements (which you may choose to increase) to your modelling cardboard. To avoid errors, make sure the cut-out pieces fit together before you fix them. Corrections can be made with scissors but— a practical hint—err on the side of allowing a good margin for hinges; you can always trim them if they seem too clumsy for a neat model. Extra ones may be necessary for a large-scale house, especially on pieces 4 and 6.

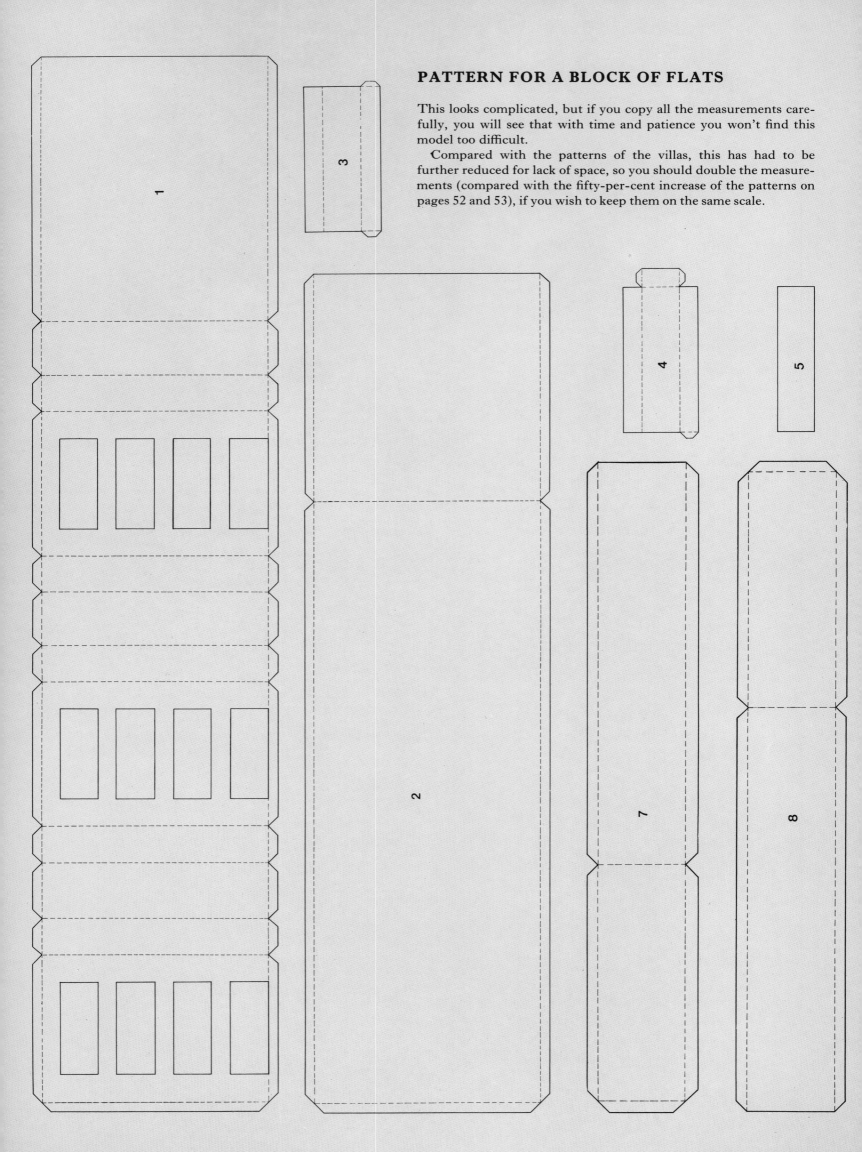

PATTERN FOR A BLOCK OF FLATS

This looks complicated, but if you copy all the measurements carefully, you will see that with time and patience you won't find this model too difficult.

Compared with the patterns of the villas, this has had to be further reduced for lack of space, so you should double the measurements (compared with the fifty-per-cent increase of the patterns on pages 52 and 53), if you wish to keep them on the same scale.

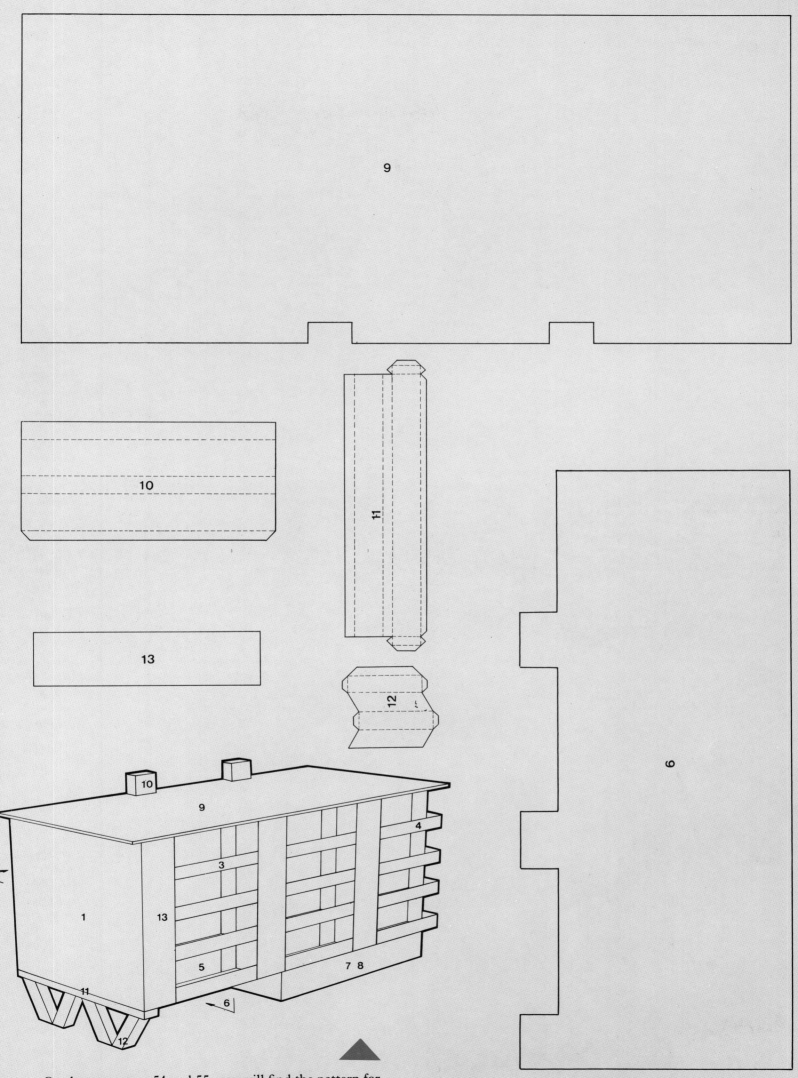

On the two pages, 54 and 55, you will find the pattern for the building reproduced here, supplied with the relevant reference numbers.

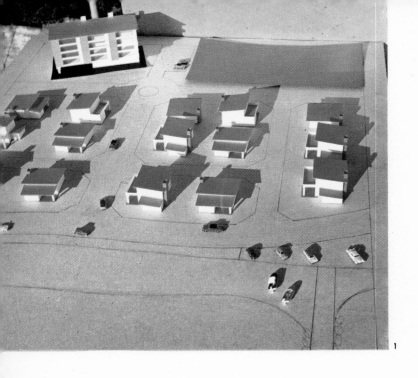

1

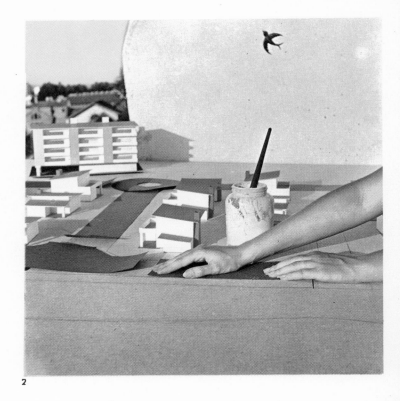

2

3

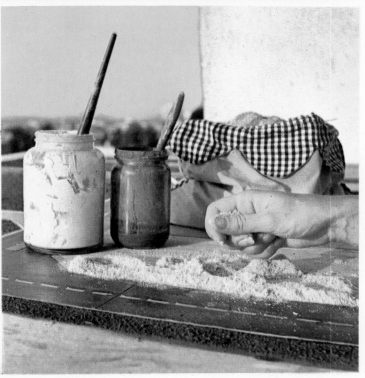

The completed project

The group work does not end with the completion of the houses. You have to discover the necessary materials for making the additional items (roads, flower-beds, lamp-standards, vegetation, sea, beach etc.). These fascinating problems can be shared out.

Here are the final stages involved:

1. *First you should transfer to the baseboard panel the ground layout plan showing the distribution of the buildings etc. Test it out by placing the various models on their allotted sites.*

2. *Now proceed to cut strips of grey paper to make the roads. When you have checked on your street plan you can stick the required strips on the baseboard.*

3. *At this point you can paint the sea.*

4. *For the lawns, prepare the grass areas by applying glue on them with a thick brush. Before it dries, shake sawdust on to the surface in such a way that it adheres only to the grass areas. When the sawdust has stuck, blow away, or remove with a duster, the surplus sawdust.*

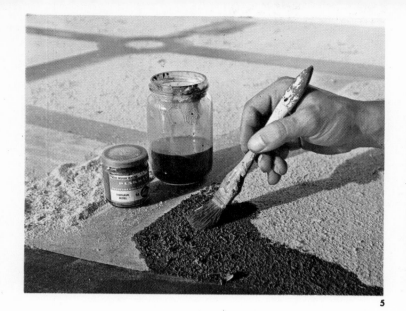

5

5. *Now prepare some green paint and apply it to the sawdust that forms the lawns. The rough surface will create the illusion of grass plots.*

Proceed similarly for the sand on the beach, leaving it of course, in its natural state.

6. *Now comes the turn of the street markings. For this, provide yourself with small strips of white and yellow adhesive tape. Cut these in small lengths and apply to the sides and centre of the roads as required, and to other areas, e.g. car parks, sports fields etc.*

7. *A few finishing touches now to complete the project. Everything is ready for the placing of the buildings. Even the street lights are in position. Bent nails produce a perfect simulation of modern street lamp-standards.*

Look at the whole model from above. The houses have been sited. It is like an aerial view of a genuine holiday estate. The work is almost finished.

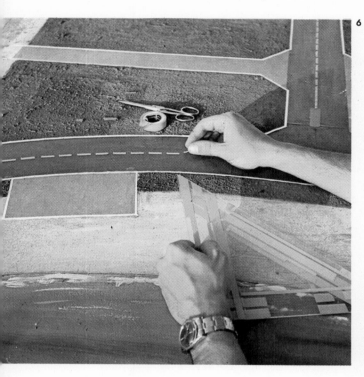

6

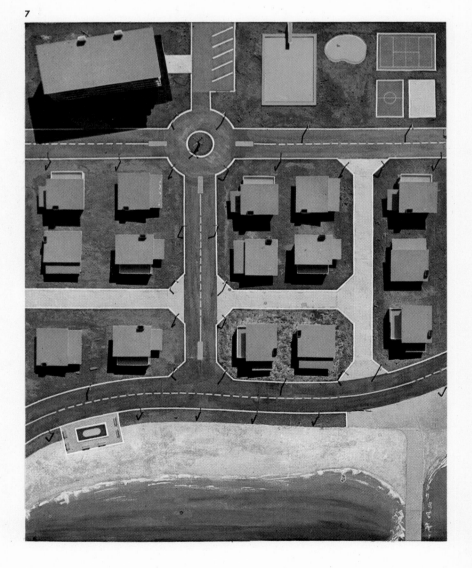

7

Practical hints

For your baseboard use wood, plywood if possible, which besides being cheap is light and manageable, and it does not warp if reasonably thick.

Use a large brush for applying paint to large areas. Allow for the fact that wood (unsized) absorbs paint and with a small brush your work would never end. You may find it more satisfactory to use a primer first.

Sever the adhesive tape by sticking it down flat on a piece of glass or formica and then cutting it with a razor-blade. The pieces of tape do not lose their adhesive qualities when applied to glass; you can easily peel them off, ready for fixing where required.

Before you finally stick down the houses etc., place them on their pre-determined sites and judge the overall effect.

The finishing touches

Now comes the most interesting part of the work. There are all kinds of finishing touches you can supply, such as the miniature cars for your park. Note how realistic the whole work looks in these colour photographs. Note that realism permissible in small details such as the model cars etc., can be overdone and should not be put too close to the less realistic parts of the model. Oddly enough, over-realistic details in houses (e.g. use of printed brick walls) tend to make models look like doll's houses.

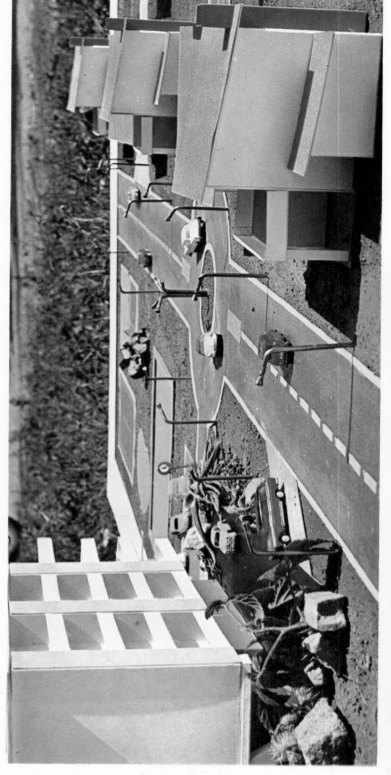

Street furniture contributes to the feeling of realism, likewise the pebbles on the beach, green foliage, benches on the sea front, sailing boats etc.

Note two partial views of the work taken from two different angles, but both bringing out the realism of the whole—to which the illuminating of the model contributes not a little.

On the facing page you can see the complete model in which you will be able to appreciate its success and the logical arrangement of all the component parts. This last-mentioned quality is essential for giving a look of professional realism to the project.

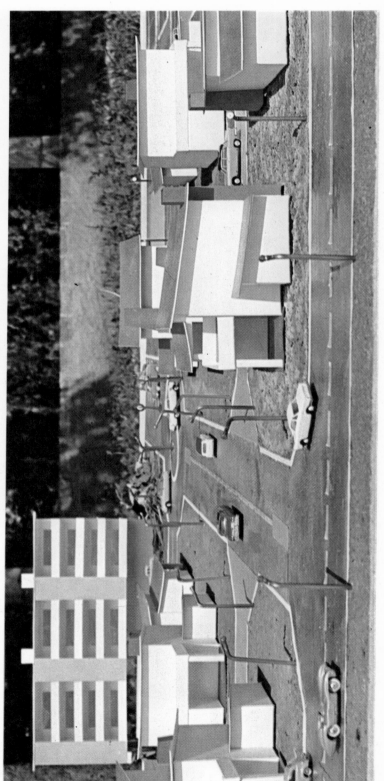

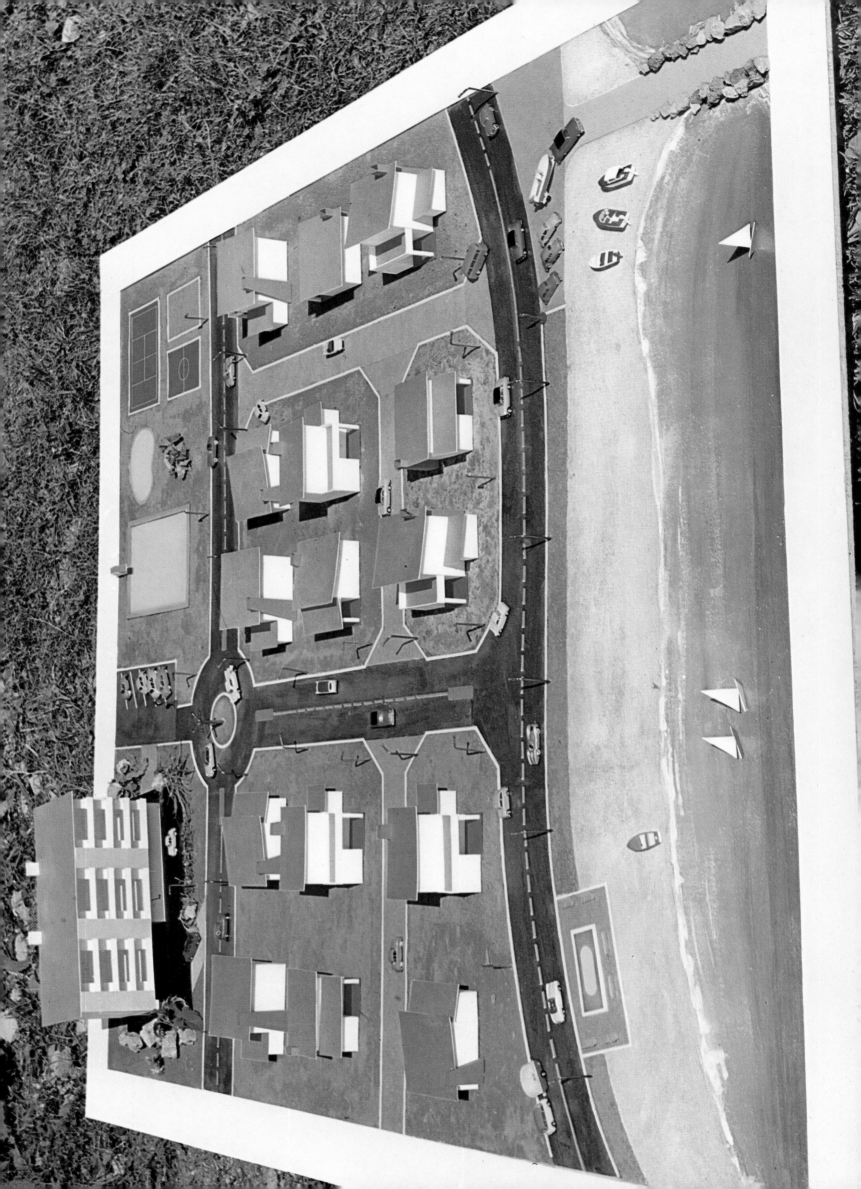

ENGRAVING

The art of engraving originated in the Far East in the tenth century B.C., but it was unknown in Europe up to the thirteenth century.

The purpose of engraving is the multiplication of prints from the same engraved plate. The drawings, pictures and photographs you see in this book are engravings but very different from those in the early medieval books. Nowadays, in fact, reproductions are engraved by photo-mechanical processes and are very faithful to the originals. Modern reproduction, however, has become a specialized technique and is totally devoid of value in the aesthetic and creative sense.

So we will forget about photo-mechanical techniques to consider various kinds of engravings as an art, that is those autographic operations whose results are the combination of sensibility, manual dexterity—and, should we add—happy accident.

The woodcut

Woodcut is a means of repeating the same graphic image or print and is the oldest known kind of engraving. It is executed on the long grain of a block of soft wood. The parts of the design which are not to appear in the print (white areas) are removed by gouges, after the lines to be in relief have been cleared with engraving knives. These lines will appear black etc. (according to the colour of the ink) on the print.

The technique imposes its own aesthetic approach based on selection. It does not permit of photographic imitation of reality, but leads to a stylization of the forms. This implies an intellectual exercise on the artist's part, a rethinking of the forms observed and an individual synthesis.

The original drawing can be done on transparent paper and subsequently traced in reverse on to the wood block. It is important to recommend the reversal of the drawing so that the print will print the same way as the original and not as in a mirror.

Everything in such prints is in black or white; there are no half-tints.

The method of obtaining copies is very simple. The inking on the engraving is done with a roller. Only those portions of the surface that are in relief will receive the ink. A sheet of paper is laid on the inked engraving. Apply pressure uniformly to this with some round hard object such as the back of a spoon and you will obtain an image which will take you back to the distant times of ancient codices on parchment.

Wood engraving

This is executed on the end-grain of holly or boxwood and allows great precision. The artist engraves the design with a graver (burin), and as in the case of a woodcut it can be in relief, printing black, or cut into the wood producing a white line against a black ground.

The drypoint

The woodcut was followed by engraving on metal, a much more elaborate technique based on an entirely different principle. The first metal engravings were done by drypoint; the design was incised directly on to the metal with a steel needle. In the drypoint the incisions will be the lines. In fact the needle raises a slight copper shaving on either side. It is this burr (unless removed to print the thin incision line only) that holds the ink and produces a tonal richness in the line.

When the engraving is made the plate is inked, but before printing, the surplus ink is wiped off. A special press is used and a damp, porous paper. The deeper incisions will produce darker and wider lines than the shallow ones. If more than about fifty copies are required, e.g. for original book illustrations, the plate needs to be steel faced. Both Picasso and Bernard Buffet have made great use of the drypoint for books and prints.

Etching

Of all the engraving techniques, etching lends itself to the widest range of artistic expression. The basic principles are those of the drypoint but it offers the possibility of chiaroscuro. Half-tones are obtained by 'working' the plate with acid for a shorter time, deeper tones by a prolongation of this 'biting' process.

First the copper plate is covered with a film of an acid-resistant substance (greasy varnish) or 'ground'. You pierce the portions which are to form your picture with a metal needle (etching needle). The plate, having been given a protective coat of varnish on the back and edges, is then immersed in a dilute solution of nitric acid. This attacks the portions of the surface where the needle has removed the ground. Ultimately ink will be pressed into these bitten parts (the picture) and create fine qualities of chiaroscuro.

Aquatint

This is a tonal process, mostly used where whole areas of chiaroscuro effects are required, less satisfactorily obtained by line and cross-hatching. Etched or engraved lines, however, can be combined with it on the same plate. Initially the plate is covered with powdered resin and is heated to make this adhere. Eventually the acid will pierce the tiny crevices left between the grains and the unprotected portions of the plate will be pitted with tiny cracks which will hold the ink, and print in various tones of grey to near-black according to the length of time the plate is subjected to the acid. In the illustration on p.61 Goya has combined etching with aquatint. He is the supreme master of the process.

Lithography

Lithography is a process for reproduction rather than one of engraving. It is used both by artists making individual prints (auto-lithography) and commercially. In the former

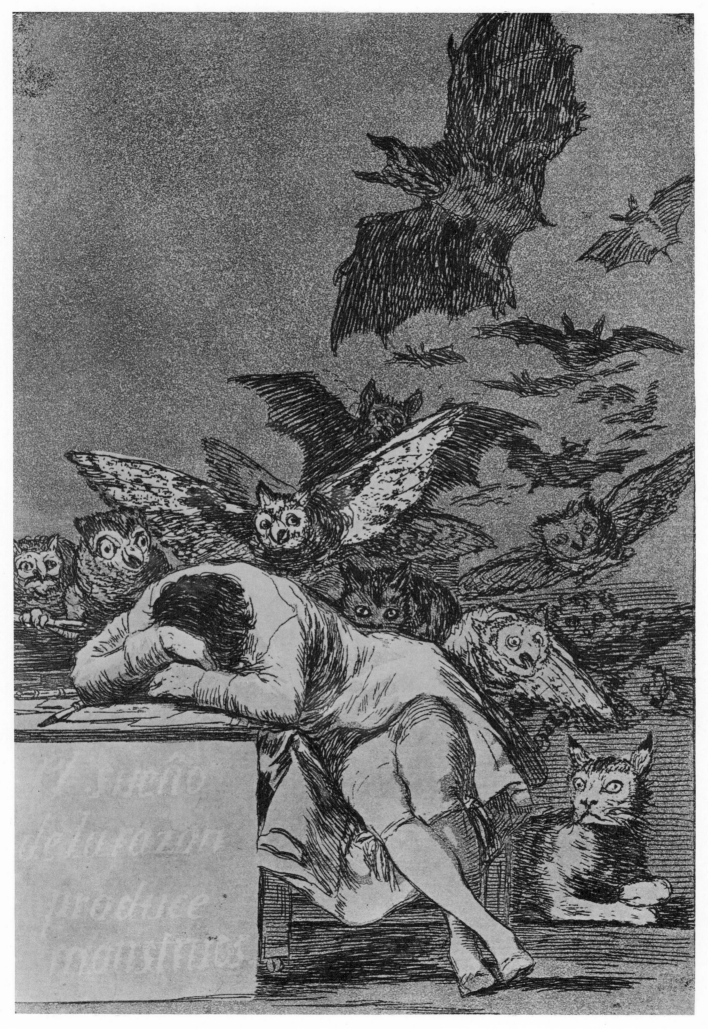

Goya: *The Sleep of Reason produces Monsters,* etching and aquatint from
Los Caprichos, (British Museum).
Goya adds the comment: 'Imagination deserted by reason creates impossible,
useless thoughts. United with reason, imagination is the mother of all art and the
source of all its beauty.'

case the artist draws with a greasy chalk on a special calcareous stone. At the inking stage, the stone is kept damp and rejects the ink which adheres only to those portions of the surface on which the artist drew with his special chalk (or ink). Nowadays for commercial printing, zinc plates replace stone since they can be bent round two sets of rollers, and the image transferred from one to the next. This process is called 'offset'. Unlike the auto-lithograph the original design is not reversed.

The linocut

All the techniques which we have looked at produce very attractive results, but they require special equipment to which you probably do not have access. But there is a material which you can easily procure, namely linoleum.

The technique of the linocut can be very like that of the woodcut, namely the principle of clearing away the parts to appear blank and preserving what is to print black. It can also be treated as a white-line process. Lino is a soft, resilient material and easy to work. Before cutting, however, you draw your subject on the surface in Indian ink so that you can see which parts to cut away.

When the cut is finished, you can think in terms of colour. There are many combinations you can make. For printing the results, use printing ink and a rubber roller. The fascination of this technique lies in the variety and surprise of the results. In fact no two copies will emerge exactly the same, even from the same cut.

Look at the two examples of linocuts on this page. The subjects are simple and decorative, just what is needed for this medium.

One factor to bear in mind is that the design will be reversed

in the print. This is not important in the examples shown here but it is a point to remember. In the first example the original cut is at the top. In the second the original cut is the one on the left.

MOSAICS

Nothing is more exciting than watching an archeological dig and seeing the gradual revelation of an ancient mosaic which has been buried for centuries. If you visit museums and have opportunities of seeing these ancient mosaics you will marvel at the preservation of their colours. This is logical since they consist of stones the colours of which are almost unalterable.

The magic of the mosaic is in its richness of colour and the simplicity of its forms. This simplicity arises from the impossibility of representing small details unless the mosaic is so vast that the fragments of stone appear proportionately small because, seen from a distance, they give the illusion of detail.

The Byzantines were the great masters of this medium. They covered their buildings with great areas of mosaics of a vivacity and richness of colour that have never been rivalled.[2]

A mosaic is made by filling the areas of a subject with previously selected stones of various sizes so that the smallest spaces have an appropriate filling. Nowadays a variety of coloured stones, squared off, ready for use can be obtained. However, if you have any problems because of lack of equipment you can obtain reasonable results with coloured cardboard or paper, as substitutes for stones. You sketch your subject, cut out small squares of glossy papers of various colours and fix them carefully and tastefully on the prepared background support of stout paper or cardboard.

Look at the magnificent mosaic in the church of S. Vitale of Ravenna reproduced below. It is a masterpiece of subtlety and perfection both in composition and colour. The figures are almost static, yet the postures and tonal gradations have an oriental flavour that is not easily imitated.

Here are two examples of mosaics by schoolboys. Note the perfection of the technique and the successful choice of colours—the main factor in mosaics.

Observe how the effect is enriched by the various angles at which the main lines of the pieces are inserted. As you examine this placing, you will realize that these carry the key lines of the whole design. This is a method to remember. Once you have fixed the stones which create your pattern, it is easy to fill in the rest of the area.

However, our chief aim in reproducing these examples is to demonstrate the attractive nature of the subjects. They are a lesson in synthesis and creative imagination that older and more experienced artists would not be ashamed of.

Massana Art School, students' work

GRAPHICS

Only twenty years ago, the graphic or commercial artist did not exist, or at any rate was not known under this label. Today he is an indispensable professional in the field of publishing and publicity. He has raised his profession to the level of an art. With his technical resources and aesthetic sensibility, he has given an artistic note to the dullest advertisement material. Often, over and above commercial requirements, his work crosses the borderline and becomes fine art. Nowadays, announcements, pamphlets, and magazines are tastefully laid out. Designs and photographs are really distinguished, the colours are studied and suitably harmonized. The choice of typefaces is made with great care.

The commercial artist then is a distinguished professional, the best exponent of applied art. His path however has not been easy. He has had to struggle—and he is still struggling—with obstinate clients who refuse to believe that advertisements can be effective and beautiful at the same time.

This involvement in publicity is not altogether a new phenomenon. In his own time Toulouse-Lautrec was associated with it. Everyone is familiar with his posters which, despite their purpose as advertisements, have become part of art history. Of course, poster techniques have changed considerably since then; but in every period artists have made their contribution by any means at their disposal.

Graphic piece by Francisco Bas

Techniques in commercial art

Technique, professionalism, continuous experiment are the hallmark of commercial art. In fact the commercial drive for increased productivity engenders a perpetual renewal, originality to the *n*th degree. The graphic artist therefore exploits every technique and is always searching for new ones. Free from prejudices, he snaps his fingers at the orthodox approach. What counts in his eyes is the final result of his work.

The graphic artist's chief ally is photography, especially the photographic laboratory to which he entrusts the major part of his ideas—various tricks, superimpositions, special effects . . . The original photographs are completely transformed into the decorative or expressive element which the artist had envisaged.

The examples of graphic design on these pages are a clear proof of the enormous variety of expression in this speciality of commercial art.

On page 65 you see reproduced the simplicity and elegance of a Christmas theme. From a magnum of champagne rise seasonable symbols in the form of champagne froth in which the only touches of colour are asymmetrically placed red bubbles.

On the left-hand page is a design on the theme of doves and stars incorporated into a single pattern in black.

On the right are doves of every colour by the same artist. The method is collage combined with 'transferred' colour (see Introducing Subjects and Skills p.34) and pieces of paper previously cut out. It could make an effective wallpaper design.

Below you can see an effective combination of photography and drawing executed for a commercial leaflet.

Below on the right is a photograph processed in the laboratory into what is virtually a drawing of contrasted masses. It is a device frequently resorted to by graphic artists.

On page 68 is a final example, a composition based on cubes, highly original and meticulously carried out.

The work on this page is all by Francisco Bas

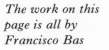

Sensibility in graphic design

It is difficult to propose a valid yardstick for judging this rare quality, since it is not just a technique but an overall awareness of what is attractive, a complete familiarity with the world of images so that one can see at a glance the aesthetic possibilities of any object or setting. Possessing graphic sensibility therefore is a problem of profession-alism in the domain of forms and colours. The main difficulty is to produce art which is subjected to the discipline of utility.

Finally we are indebted to commercial artists for the popular diffusion of art, since they follow the trends of avant-garde movements and, through the medium of advertisement, general publicity and book production, pass them on to the man in the street.

ART APPRECIATION

During the period of time you spend following these three books you will learn something about art and art techniques. Judgement and practice however are not enough; you need to back up this personal experience with further knowledge and appreciation of masterpieces of painting.

Civilization is a continual process; it means adding new discoveries to those that our predecessors have already made. For this reason it is indispensable for us to have some knowledge of the history of art since, artists or not, we must carry on the tradition. The isolated artist who has never seen a picture does not exist. If he did it would mean that he was outside his own time and would have to conduct alone all the experiments which his predecessors took centuries to perfect. Let us be frank: what would you say about a great painter who did not know who Michelangelo was? Or the Renaissance? You would be right to consider him an ignoramus. This is why you must clear the last

hurdle and survey the glorious development of the history of art. We shall be dwelling this time on the history of painting, representative art of each movement and tendency covered in these books.

Aspects of art appreciation

A proper appreciation of art should embrace three basic items:

Knowledge of the historical and social events of each period.

Knowledge of the painters of each period.

Understanding of the aims behind the development and significance of the various styles and tendencies.

When you know something about these three aspects of the history of art, you will be more prepared to widen the scope of your art appreciation in the future as you become interested in everything concerning the development of art.

The history of painting

As an appropriate finale to this part of *Alive to Art* we have provided a history of painting or rather a ten-page summary of seven centuries of art evolution, seven centuries of turmoil, events, opposing tendencies which give us the measure of the continual fluidity of art and the individual points of view of the artists. The story begins with the early Renaissance and ends with our own time and during this long period you will see how the gap gradually widens between one extreme and the other. This condensed survey will serve to stress these differences. Inevitably this can only

be a superficial résumé aimed at opening doors on to the complex world of art. The comments and examples set before you will provide you with a basis for a deeper study as time goes on, supplemented by reading and frequent visits to art galleries.

Note the planned layout of the pages that follow. It should help to draw your attention to the sequence of the four basic lessons set out for you: historical periods, the painters of each period, aims behind each movement or school and reproductions of relevant paintings.

Historical period

Representative painters of the period

Aims of the art movements

Paintings illustrating the period in question

From 1400 to 1500
THE RENAISSANCE BEGINS

The cradle of the Renaissance is Florence under the aegis of various Florentine families. The one which emerges as the most important is the Medici to which the art of the period owes so much.

Feudalism gives way to a new civilization; everything changes and is renewed. Classical art is studied under a new light, resulting in the birth of the principal art movements of history.

Although he died very young **Masaccio** (1401–1429) is the true precursor of modern painting. Others of his period are **Paolo Uccello** (obsessed by perspective), **Pollaiuolo**, **Verrocchio** and **Fra Filippo Lippi.**

In the second half of the fifteenth century, **Sandro Botticelli** with **Domenico Ghirlandaio** are the great painters of the time.

Mantegna, with his realism and extraordinary mastery of perspective, stands out as the most important Renaissance master in Northern Italy.

Painting enters a new phase; it becomes a major art. The Renaissance artists shun the static figures of the past and try to give animation, reality and above all humanity to their works.

Their main preoccupations are with atmosphere, perspective and form. Art makes a great advance in its search for freedom of expression. Nevertheless this period was only the first step on the road towards the High Renaissance.

From 1500 to 1600
THE RENAISSANCE CHANGES ITS CENTRE

Like a patch of oil the Renaissance extends throughout the whole of Italy. From the Florence of the patricians it moves notably to the Rome of the great popes. Indeed, so great was the influence of the pope that this period was called the 'century of Leo X'. For those under the influence of the great buildings of the Eternal City this led to a grander and more spectacular art than that of Florence.

This was the period of the great masters. In Rome and Florence: **Michelangelo, Raphael, Fra Bartolommeo** and **Andrea del Sarto.** In Venice: **Giorgione, Titian** and **Veronese;** in Milan and Florence: the great **Leonardo da Vinci**, the epitome of this golden age of Italian and universal art.

It is difficult to make comparisons, especially between different periods, but Leonardo and Michelangelo stand firm as universal geniuses for all time.

In this century the Renaissance achieves its true goal and comes to its full maturity.

The individual freedom of the artist is a reality. Art becomes increasingly personal, and in their search for beauty artists are inspired by antiquity, true masters in this sense. Yet, in this 'renaissance' they exploit all their knowledge, new techniques and especially their new ways of looking at life. The Renaissance does not then copy antiquity, but neglecting the medieval parenthesis, it improves and fosters its development.

From 1600 to 1700
THE BAROQUE

This movement arises in Italy in the later sixteenth century. Its precursors are Michelangelo, Tintoretto and Correggio. The new style extends to Spain and Southern Germany but it encounters some resistance in France where classicism was so deeply rooted. In Northern Europe it is completely ignored.

In Italy art changes its seat again. After Florence and Rome, comes the turn of Bologna, the city of the intellectuals.

In Italy **Ludovico Carracci** creates his own school of painting. However, **Caravaggio's** crude realism exemplifies the true characteristic of this period.

In Spain we find **Ribera** (who follows in Caravaggio's footsteps), **El Greco** (with his strange distorted forms) and the great **Velasquez.**

In the Low Countries **Rembrandt** is the undisputed genius. In France, **Le Brun** triumphs at Versailles.

In this period realism is complete. Painting reaches a degree of naturalism hitherto unequalled. Caravaggio is the true promoter of this new development.

At the same time Rembrandt makes an outstanding discovery: **chiaroscuro.** This new technique represents a giant stride towards the conquest of atmosphere, ambience and volume. It is the period of vast canvases for palaces, life-size portraits and elaborate compositions, full of imagination and vigour.

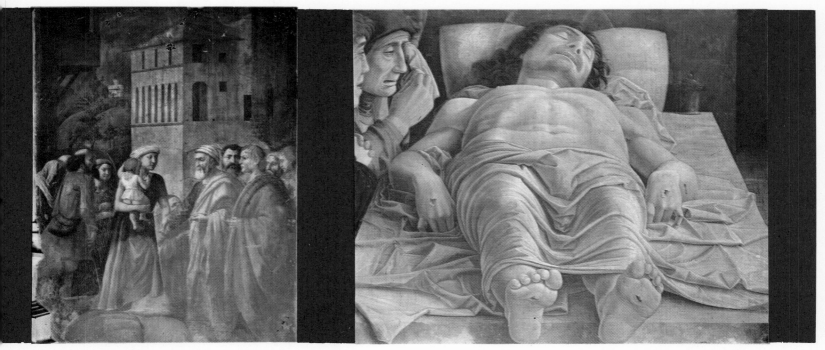

Masaccio: *St. Peter Distributes Alms to the Poor*

Mantegna: *The Dead Christ*

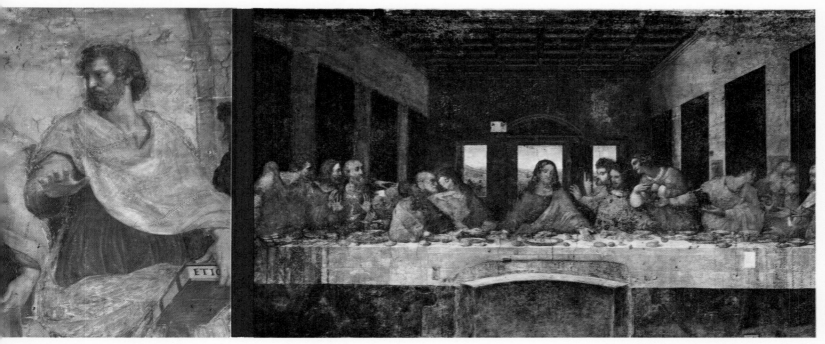

Raphael: *Aristotle* (detail)

Leonardo da Vinci: *The Last Supper*

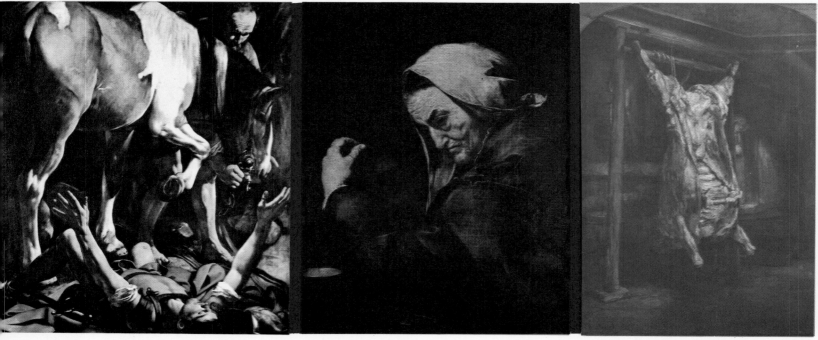

Caravaggio: *The Vision of St. Paul*

Ribera: *The Old Usurer*

Rembrandt: *The Slaughtered Ox*

1700
THE ADVENT OF ROCOCO

France now replaces Italy as the art centre of Europe. This change is due to the great prestige enjoyed in Europe by the century of Louis XIV. In fact every country attempts to imitate its palaces, customs, splendour . . . Versailles was the new Parthenon.

Only England and Spain succeeded in avoiding this artistic dictatorship.

Watteau is the greatest French artist of this period. His favourite subjects were *fêtes galantes*.

The atmosphere in Italy was propitious for the introduction of the Rococo. **Giovanni Battista Tiepolo** creates a consistent illusion in his ceiling paintings by his bold foreshortenings, while **Guardi** and **Canaletto** make Venice immortal.

In France the painter **Vien** signals the return to classical antiquity.

It is the period of bucolic subjects, of 'sweet' painting, swooning ladies, minuets, flowered ornaments. However it cannot be denied that Rococo has a character of its own; the beauty and complexity of the works of this period are of indisputable and especially of technical value.

Nevertheless, as is always the case with extreme tendencies, the reaction, no less extreme, soon occurred. Diderot and Vien were the spokesmen of the general weariness.

Second half of the 18th century
GOYA, AN HISTORICAL PARENTHESIS
The birth of modern art

Europe was undergoing one of the major transformations in history. With the disappearance of the influence of Louis XIV, the French Revolution led to a new concept not only of society but of life in general. So great a change could not fail to upset art which was now seeking out new paths that led to a new reality.

Meantime, in Spain, a solitary painter on the fringe of the artistic currents of the period, and in opposition to his own ambience, was laying the foundations of modern art.

Francisco de Goya y Lucientes was the inspiration behind the whole of nineteenth-century painting. Born in 1746, he became symbolic of an art free of all prejudices, social and political.

Profoundly revolutionary and self-critical, he saw the world through very human eyes. Spain of the period with its superstitions and ignorance drove him to denounce and criticize it unmercifully. The outcome of his lonely struggle was an expressive force so strong as to point the way to completely uninhibited painting.

Goya's painting was much abused in his own time. He was accused of vulgarity and lack of artistic composition in the conventional sense. People failed to understand that this in fact was his real strength.

Goya was a master of transparent glazes, reflections, vibrant colours. He painted with the palette-knife, the sponge and . . . his fingers. Reality, not realism was his aim. Therefore he participated in the reaction against unsubstantial painting. His reaction was not however in the direction of neo-classicism or other tendencies of the period but towards freedom and expression taken to its logical extreme.

The end of the 18th century
NEO-CLASSICISM

On the fringe of the isolated work of Goya, art underwent a profound transformation in the wake of recent historical events.

The first to invade the field of art, now no longer the privilege of the powerful but a means of expression available to anyone, was the spirit of the French Revolution. Next, the Empire became the cause of a return to classicism. Napoleon's dream was to create a new Roman Empire, modelled on that of the last of the Caesars.

Classical austerity took a new hold on art and so violently that Baroque very quickly became a mere memory.

Jacques-Louis David was the most representative neo-classical painter. His works were in line with the most rigorous classical discipline. His compositions were based on uncompromising theories which admitted of no concessions. The more moderate **Géricault** took classicism in the direction of realism whereas **Ingres** moved towards romanticism.

Meanwhile in England something happened: the landscape was born. **Constable** was one of the creators of this new art. His influence was to extend beyond his century and have a lasting effect.

Restless years for painting, something is in the air: on the one side a return to classical antiquity, on the other the birth of Romanticism, and between these two extremes various tendencies of contrasting aspects.

Colours undergo a notable revolution which anticipates the approaching century; meantime the most complete realism spreads from France throughout Europe.

The English landscape painters, headed by Constable, and the disciples of the new colour tendencies of Delacroix, seem to give a decisive stimulus to the vital epoch that is approaching.

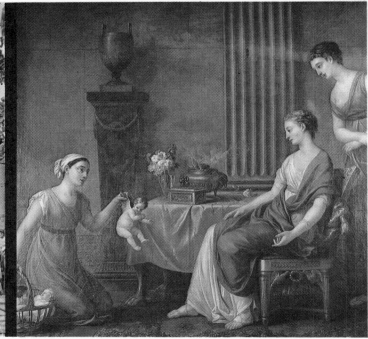

Watteau: *Venetian Feast* Tiepolo: *The Marriage of Frederick* Vien: *The Vendor of Cupids*
Barbarossa

Goya: *3 May 1808* Goya: *Pilgrimage to the Fountain of*
St. Isidoro (detail)

David: *The Death of Marat* Ingres: *The Apotheosis of Homer*

The first half of the 18th century
(from 1800 to 1863)

OPEN-AIR PAINTING

The century opened under the dominance of Romanticism. This time the initiative came from the English. Their traditional love of nature led them to concentrate on landscape. This aroused a hitherto latent desire in the rest of Europe.

A new technique materialized: water-colour. The first society of water-colourists was founded in 1805. Art had finally become democratized and even the man in the street felt free to make his own artistic contributions.

Turner followed the tradition of **Constable, Bonington** and **Baron Gros** but gave his works a richness, almost impressionistic in their atmospheric effects.

French painting is represented by **Delacroix,** the revolutionary of colour, also by **Millet, Courbet, Corot** and many others. **Manet** takes a fresh step forward, picking up his easel in order to paint in the light and the sun.

In this period, after a romantic preamble, art gradually finds its way again. It is the time of the portable easel; the artist seeks his subject *in situ.*

Manet's painting *Le Déjeuner sur l'herbe* caused a scandal in artists' circles. They were staggered by the subject, setting and particularly the brilliant colours.

As happens with every innovation, open-air painting did not escape controversy, but there is no doubt that it gave art a new direction.

The year 1863
IMPRESSIONISM IS BORN

This movement was baptized by a witty journalist commenting on Monet's painting entitled *Impression, Sunrise,* exhibited in 1874. Like all art movements, however, Impressionism was not the work of any single painter but a development of the painting of the period. Even before the movement had gained its name, Impressionism had been adopted by several painters, especially by that group of painters who, out of pique, organized the *Salon des Refusés* in Paris in 1863.[3]

To this period belong: **Claude Monet,** the first painter to set the official seal on the 'impression', **Pissarro,** Monet's disciple who followed his master's path but with slightly more realism, **Sisley** (son of English parents) in the landscape tradition, **Degas,** the realist who gradually understood and practised the new art, and finally the great **Renoir.** It was he who perhaps best personified late Impressionism.

The sense and aim of Impressionism was to replace the dark colours and the solid forms of the realists with a new conception of light and of life. Artists felt the need to get away from the dusty studio, to go out into the open air, and, above all, to employ bright, clear colours. They endeavoured to catch the fleeting changes of light.

Spanish and especially Japanese painting greatly influenced them but this in no way detracts from the extraordinary and unforgettable mark that Impressionism was to continue to make on future painting.

Towards the end of the 19th century

REACTION AGAINST IMPRESSIONISM
(Post-Impressionism)

While Impressionism triumphed throughout Europe, avant-garde artists tenaciously explored new avenues in art. New groups, new styles followed the perpetual forward movement in their search for new forms and idioms. They include the Nabis (prophets) under the impetus given by Gauguin, the Naturalists, the Modernists, the Synthesists and the Symbolists. We are on the threshold of the twentieth century.

Paul Cézanne was the first to rebel against the type of vibrating brush-strokes, the sole aim of which was to capture light and atmosphere. He used simple, natural colour, applied in solid and contrasted areas which had sufficient strength to animate his subjects.

Van Gogh, with his strange madness, brought violence and audacity to painting.

Gauguin, traveller to the South Seas (Tahiti), encountered primitive art and mastered new and harmonious forms.

Toulouse-Lautrec, the crippled genius, in his works tried to express the drama of life.

We are in the pioneer period of twentieth-century painting. Pointillism, the play of light, vibrating colours have ceased to interest. Painting had lost volume and colour was used to recapture it—clear, constructed colour, strong, bold but studied and, above all, felt.

Now form loses its importance under the influence of Primitive painting.[4] Thus an art of simple, almost childish style, but very expressive in content, comes into being.

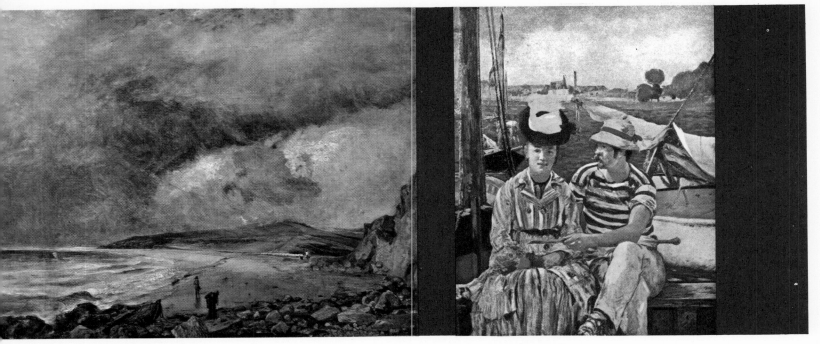

Constable: *Weymouth Bay at the Approach of a Storm*

Manet: *Argenteuil*

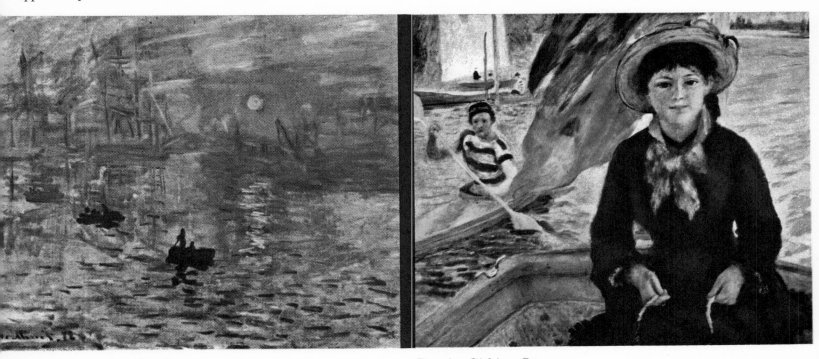

Monet: *Impression, Sunrise*

Renoir: *Girl in a Boat*

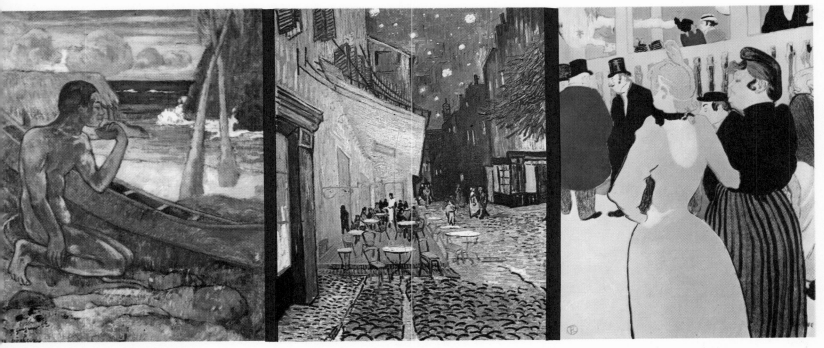

Gauguin: *The Poor Fisherman*

Van Gogh: *Café in the Evening*

Toulouse-Lautrec: *La Goulue and her Sister at the Moulin Rouge*

The year 1904
EXPRESSIONISM

This movement was born in Dresden, Germany, and concerns the work of a group of painters known as *Die Brücke* (The Bridge). As the name implies, their aim was to serve as a bridge between Naturalism, Impressionism and Abstraction. This style of painting came to its maturity during the First World War.

But Expressionism was not confined to Germany; kindred movements arose within a few years at various places in Europe and especially in France.

The Expressionist pioneer was **Ernst Ludwig Kirchner,** founder of the Dresden group composed of **Heckel, Schmidt, Nolde, Müller** and **Pechstein.**

Expressionism in France developed in a different way. Of its exponents, **Rouault** most closely approached the Germanic tendencies.

Expressionism, as the term indicates, is a movement that aimed at expressing ideas and emotions. Nevertheless, it still remained representational, while showing a strongly marked tendency towards depictions of a symbolic or emotional character. The subject became distorted and all the emphasis was on the strength of feelings evoked. Painting became a free expression of the artist's emotions, no longer subjected to formal discipline.

The year 1905
FAUVISM

Almost simultaneously with German Expressionism, a similar tendency arose in France, but possessing its own character. This new painting was so violent that its originators were nicknamed *fauves* (wild beasts). The origin of this name, like so many others, was accidental, being attributed to a critic. He was visiting the *Salon d'Automne* in Paris, where, in 1905, the most fanatical painters were exhibiting, and looking round remarked, '*Donatello au milieu des fauves*' ('Donatello among the wild beasts'), alluding to a sculpture by Donatello in the middle of the Salon. The phrase took on and gave its name to this artistic current.

The leader of this group was the still very youthful **Henri Matisse.** He painted with the brightest colours with a complete disregard for chiaroscuro. Other warriors in the same group were: **Derain, Vlaminck, Dufy, Rouault.**

However, the initiators, albeit indirect, of this movement had been **Van Gogh** and **Gauguin** whose volcanic genius had inspired the *fauves* and also the German Expressionists.

Although the *fauves* were near-Expressionists, they shifted a considerable distance away from the German concept which, for reasons of geography and character, was more dramatic and negative. The French Expressionist movement sought a new reality, one that should explode in the picture itself and communicate its feeling to the world. As opposed to the German message, it was a feeling of *joie de vivre* (in fact the title of a picture by Matisse, 1906). Fauvism, in this new reality, showed colour and decorative value as the chief elements of expression.

The year 1908
CUBISM

This century of artistic transformations has seen many movements and tendencies, all of brief duration but of undoubted importance.

In 1907 Picasso painted *Les Demoiselles d'Avignon,* unambiguously cubist. But it was the following year when Matisse, criticizing one of Braque's pictures, remarked '*trop de cubes*' (too many cubes) and thus, without knowing it, was baptizing the new way of painting.

Pablo Picasso, Braque, Fernand Léger and later **Juan Gris,** coming from different parts of the world and various artistic schools, met in Paris and proclaimed themselves members of the Cubist family.

In Italy too the movement reached a climax, but it had different characteristics. Italian Cubism was orientated towards Futurism *(futurismo)*, whose chief exponents were: **Marinetti, Giacomo Balla, Umberto Boccioni.**

Cubism can be seen as a delayed extension of the painting of Cézanne who had been so devoted to the study of simple forms, volumes and preoccupation with areas of colour.

The image became synthesized in geometrical shapes, analyzed, constructed, almost as if they were intended to represent volumes seen simultaneously from every possible angle.

Later this concept led to collage, a genuine technical discovery since, for the first time in history, the use of extraneous materials was sanctioned in an actual painting.

Kirchner: *Under the Snow* Rouault: *Horseman at Sunset*

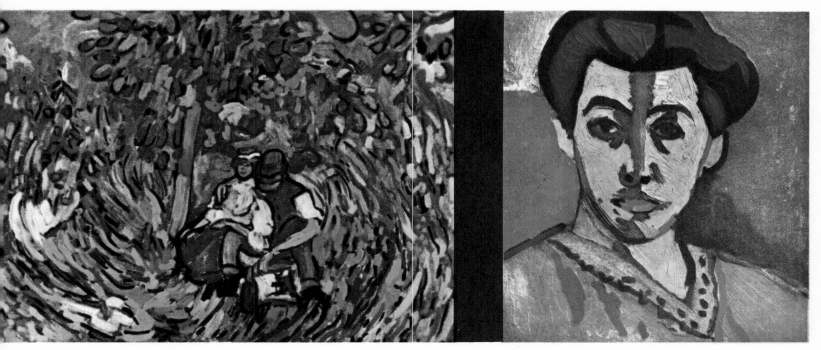

Vlaminck: *Country Picnic* Matisse: *Portrait with the Green Line*

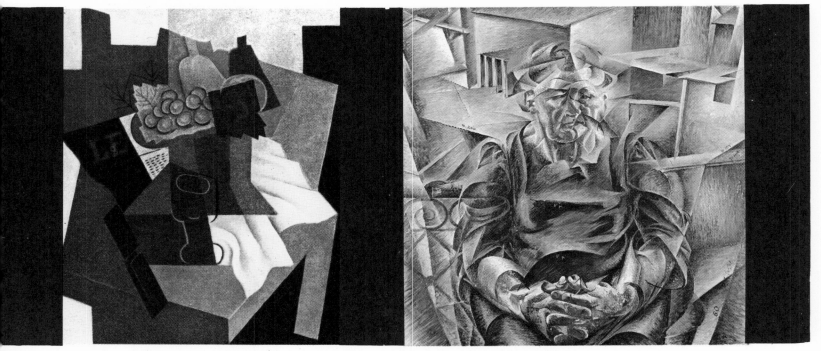

Juan Gris: *Still-life with Fruit Dish* Boccioni: *Horizontal Volumes*

The year 1911
METAPHYSICAL PAINTING

The genesis of a new kind of painting did not mean that every artist would accept it. On the contrary, Expressionists, Fauves, Cubists, Symbolists, Futurists lived side by side, influencing each other and perfecting their own styles.

In this climate Giorgio de Chirico, the Italian artist, after a Cubist phase, created a new kind of painting which was to find an immediate place among the host of tendencies of those exciting years of the history of art: Metaphysical painting. He was the precursor of Surrealist art and today is still a force existing along with many other contemporary tendencies.

Many painters, especially Italians, are in the avant-garde of this strange and disturbing tendency. Among them we find **Giorgio de Chirico.** Born in Greece of Italian parents, he received his art education in Florence and also Munich. Because of this, his style, though Florentine, has its roots in German Symbolism. Other noted artists in this vein are: **Alberto Savinio,** de Chirico's brother, **Carlo Carrà** and **Giorgio Morandi,** painters who in their turn were to find new forms of expression more characteristic of themselves.

In this kind of painting the ambience acquires a supernatural power, a mystery which radiates from the violent play of light and shadow, from an unrealistically accented shadow, from the feverish atmosphere. This painting seems to have escaped from a nightmare or to have been inspired by supernatural subjects.

The construction is based on contemporary theatrical and architectural themes. Although the whole thing is distorted, each detail is depicted with an accurate not to say exaggerated realism. Metaphysical painting opened up new avenues of expression which have not yet lost their contemporaneity.

The year 1924
SURREALISM

In his Surrealist manifesto, André Breton described his movement as 'dictated by thought outside every control exercised by reason, outside every aesthetic and moral consideration'. Surrealism in fact arose from the metaphysical ambience of de Chirico, Carrà and Morandi who sought a wider area of subjects and carried out still deeper investigations into the strange world of the subconscious.

This kind of expression still continues but represents not so much an art development as a way of looking at things.

The first Surrealist exhibition took place in the Galerie Pierre in Paris in 1925. The exhibitors were: **Hans Arp, de Chirico, Max Ernst, Paul Klee, Man Ray, André Masson, Joan Miró, Picasso** and **Pierre Roy.**

Despite the fact that the movement was directed by Breton, Max Ernst's variety and profundity entitles him to be considered the central figure of Surrealism.

Other Surrealists are: **Yves Tanguy, René Magritte, Félix Labisse, Roberto Matta, Wolfgang Paalen** and the Spaniard **Salvador Dalí,** famous for his eccentricities and not inconsiderable talent.

More than a mere artistic development, Surrealism is a delving into the mind for subjects. It is not a search for form, colour, harmony; its aim is rather to transmit a message, create a symbol, animate an idea.

While painting moves towards abstraction, the full significance of colours, the absence of forms linked to reality, Surrealism remains a psychological experiment, often put in the service of illustration and stage sets.

The present day
ABSTRACT ART

Abstract painting is not a new phenomenon. In fact this tendency arose in the first decade of our century when it lived side by side with all the movements already described: Expressionism, Cubism, etc.

As for the date of its official birthday, we can assign it to the year 1917 when Kandinsky declared that he had painted the first Abstract subject.

The creators of this new art were the Russians and the Dutch. Its universal acceptance, however, must be attributed to its enthusiastic adoption by the North Americans.

Two painters symbolize Abstract art: the Russian **Wassily Kandinsky,** inspired by Cézanne and the Fauves, and the Dutchman **Piet Mondrian,** influenced by the Cubists and himself responsible for the American movement towards Abstract art.

There are too many Abstract painters to list. Among the most famous are: **Malevitch, Annenkov, Chagall, Klee, Le Corbusier** (the famous architect), **Ben Nicholson, Arp, Sironi, Magnelli, Prampolini, Jackson Pollock, De Staël, Glarner, Parsira, Gorky, Tobey, Klein, Motherwell, Miró, Tapiès, Failer, Patrick Heron** and a great many more who are still painting in this original style.

When Persian or Arab artisans made a carpet or filigree work, they were executing 'abstract' art. In these countries there have always been geometrical or decorative designs which, without meaning anything, were deemed beautiful. Abstract painting has raised them from the level of craftsmanship to that of art, giving them added strength and harmony.

Kandinsky and his disciples wanted to make music with colours. Mondrian and Klee have inspired modern decoration, architecture and publicity graphics. Tapiès conveys the beauty of the material as material. However, this movement is not an end but, since art is inexhaustible, merely a new point of departure.

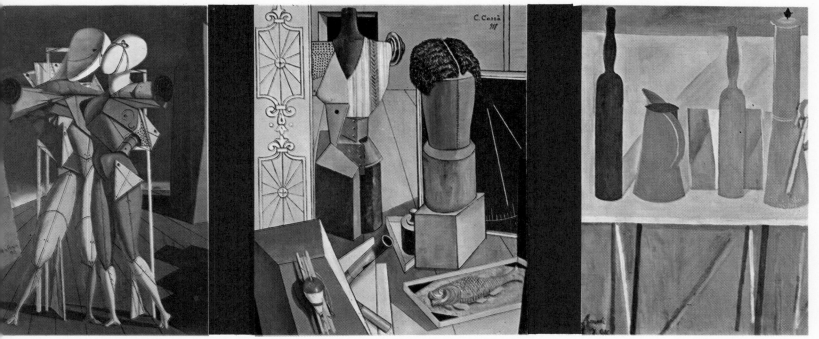

Chirico: *Hector and Andromache* · Carrà: *The Haunted Room* · Morandi: *Still-life*

Max Ernst: *After Me, the Dream* · Dalí: *Corpus Hypercubus* (detail) · Miró: *The Lovers' Complaint*

Kandinsky: *Composition 609* · Picasso: *Ox-skull* · Tobey: *City Morning*

Translator's notes

1 (p. 43). Henry Moore told me that this was the case when he was carving the heads of the king and queen in Clipsham stone for below the labels of the west porch of Much Hadham church, Herts. The use of this stone was dictated by the stonework of the whole doorway and not of course by its suitability for sculpture.

2 (p.63). There has been a revival of mosaic-making in connection with modern building in England. John Piper, for example, executed a remarkably fine and extensive one on a religious theme for the church of St. Paul's in Harlow New Town, Essex, and there is an outdoor mosaic at the new town of Hemel Hempstead, Herts.

3 (p.74). The Salon, an annual showing of painting and sculpture, corresponding to our Royal Academy, was at this time an extremely conservative body and all the avant-garde artists (including Manet, Pissarro, Cézanne) were excluded. Napoleon III therefore ordered a special exhibition of their works which became known under the title *Salon des Refusés*.

4 (p.74). Primitive painting: here the term refers to the work of amateur artists (*peintres du dimanche*, Sunday painters) who without training achieved a high degree of original expression. The best-known example is Henri Rousseau, known as 'Douanier' Rousseau because he was an official in the Customs and Excise. There is a whole room devoted to modern Primitives in the Musée d'Art Moderne in Paris. Alfred Wallis is a notable English example (collection at Kettle's Yard, Cambridge).

Some recommended books

General

BRION, Marcel, trans. W. J. Strachan, *German Painting, 15th Century to Expressionism*, Tisné

CLARK, Kenneth, *Civilisation*, BBC and John Murray

CLEAVER, James, *A History of Graphic Art*, Peter Owen Ltd

DORIVAL, Bernard, trans. W. J. Strachan, *Twentieth-Century Painting, Nabis, Fauves, Cubists*, Tisné

MURRAY, Peter and Linda, *A Dictionary of Art and Artists*, Penguin Reference Books

The Picture Encyclopedia of Art, Thames and Hudson

READ, Herbert, *A Concise History of Modern Painting*, Thames and Hudson

SERULLAZ, Maurice, trans. W. J. Strachan, *Impressionist Painters*, Tisné

Detailed

BUCKLAND-WRIGHT, John, *Etching and Engraving*, Studio Publications

CURWEN, Harold, *Printing*, Puffin Picture Book

CURWEN, Harold, *Processes of Graphic Reproduction in Printing*, Faber & Faber

A Dictionary of Abstract Painting, Methuen

HERBERT, Kurt, *The Complete Book of Artists' Techniques*, Thames and Hudson